For Karen and Steve

PHOTOSCAPES AND THE EGG

PHOTOGRAPHS AND WORDS
PATRICIA Z. SMITH

FOREWORD
STEPHEN NACHMANOVITCH

DESIGN
LOUISE BRODY

FOREWORD

These beautiful, intriguing images suggest worlds within worlds, a luminous opening through which we might peek. In an age when mechanistic thinking pervades our daily lives, it is important for us to be constantly reminded that we are biological beings living in a biological world. Life keeps asserting itself all around us if we stop to look, listen, touch, and smell. We live in a digital age but the future is analog.

The World Egg is a feature of many mythologies, of much poetry. And when we look around us and study natural history, we find it everywhere. There was James Joyce in *Finnegans Wake* talking about the four phases of the world–cycle that keeps tumbling us around age after age: eggburst, eggblend, eggburial, and hatch–as–hatch–can.

The powerful symbolism of the egg asserts the feminine, the biological, the lyric.

This art—the words and the images—are the essence of the lyric. Personal, organic, tending as Sappho is said to assert that that which one loves is beautiful. In a world where Patricia Z. Smith writes we are "addicts to divisions" she also writes:

Such small capsules we are
but we have purpose and meaning
and must try to live up to it.

This is a hell of a time in world history to live up to the challenge of being fecund, productive of life, productive of the round analog reality of life—all the more so as the waters rise, as the air gets smoky, as the nations clatter against each other with angry fearful maneuvers. From the first egg to the last, life beckons us to look up and out across our divisions, to listen with the birds and see with the eyes of flowering plants, to remember we are all part of the earth together. As Joyce wrote:

> *Lead, kindly fowl! They always did: ask the ages. What bird has done yesterday man may do next year, be it fly, be it molt, be it hatch, be it agreement in the nest.*
> *– Finnegans Wake*, p.112

Patricia's work seems aligned with the Orphic and visionary traditions going back many centuries. One thinks of Blake, the alchemists, the Gnostics, and, of course, Jung playing with sacred geometry and with DNA, with images of life and death and transformation. Can we live up to the challenge of Smith's cover image: the dark purple egg, the golden wiggly spiral worming its way around, the periphery and the center? Yes, it's a metaphor for the big Self that appears when we realize we are part of the organic world with all its changes, its being born and dying and transforming, but, yes, too, it challenges us to become aware of the supernal beauty of ordinary objects that we usually disregard.

Stephen Nachmanovitch
Author of *The Art of Is* and *Free Play*

WHY PHOTOSCAPES?

Without things in time and space there would be no time or space. Wherever creation comes from it has a debt to phenomena. Such a jumble! Isn't it such a jumble?

Does creation exist without the things it creates? Is creation required to be a thing in order to create?

No matter. The weave of phenomena, warp and weft and weight, colors and tones, sounds, waves—oh, yes, the waves of it!—oceans, wiggling worms, the stratosphere and concertos fill the space they create in the time they create it. Which came first, the chicken or the egg?

When the first big egg hatched, myriads poured out, including you reading these lines, individually conscious inside total consciousness. So, gather in the goods, meld them together, do the communal dance, explore tunnels, blooms, hills, smells, and tastes until your senses are full to the brim and mind dazed by impossibilities. Overdose on sensory perception.

Perceive yourself, others, nature, the tapestry as a whole and in sections. Let your heart receive and give.

I create kaleido-washes, collages, melds, and blends. They are my Genesis story.

All photos, and images in the photos, were taken by Patricia Z. Smith on the iPhone 11 Pro.
Composing of photos was done with the photo editing function on the MacBook Pro.

Notes and attributions for photos on page 102.

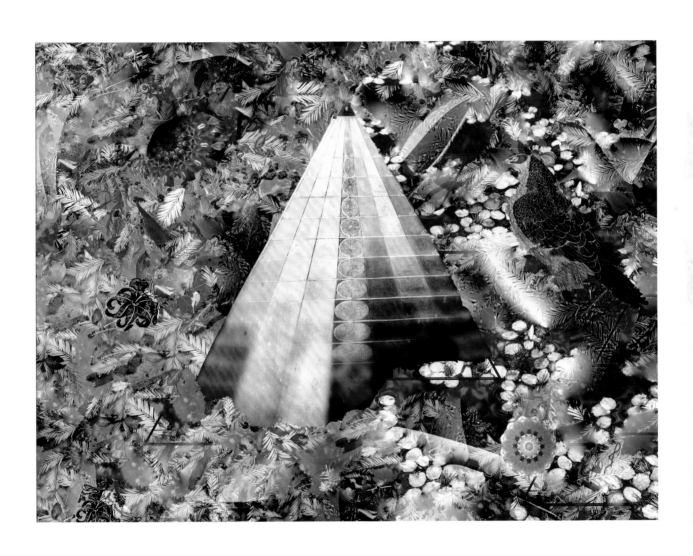

WHY EGGS?

The shell of an egg is elegant, shaped to exit a fowl easily while protecting the genesis of new life. It has no frills, no useless accessories, no glitter, no claim to beauty except its perfect self. Eggs fit nicely in our human hands, which surely factors into our primal appreciation. The affinity between eggs and humans has a long history.

The eggs in this book are intended to represent the birth of everything, including the cosmos that contains us and the cosmos we contain. They hold energy, silent knowledge, and consciousness becoming real in time and space. Sometimes, though, they are just wry or silly.

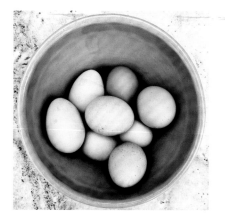

The series in this book began with eggs in pink, blue, and green, gifted by a neighbor who received them from her friends who raise exotic chickens.

This is how obsession can begin, from a first glance or taste or touch that tendrils its way inside you, growing into a lover (or demon) demanding our senses and devotion—and, so, eggs came to occupy my visions and work, taking on personalities demure and aggressive, telling stories to be deciphered.

The form of all eggs with shells escapes top–bottom symmetry while embracing sideways symmetry. It seems a gracious language with meanings we cannot put into words.

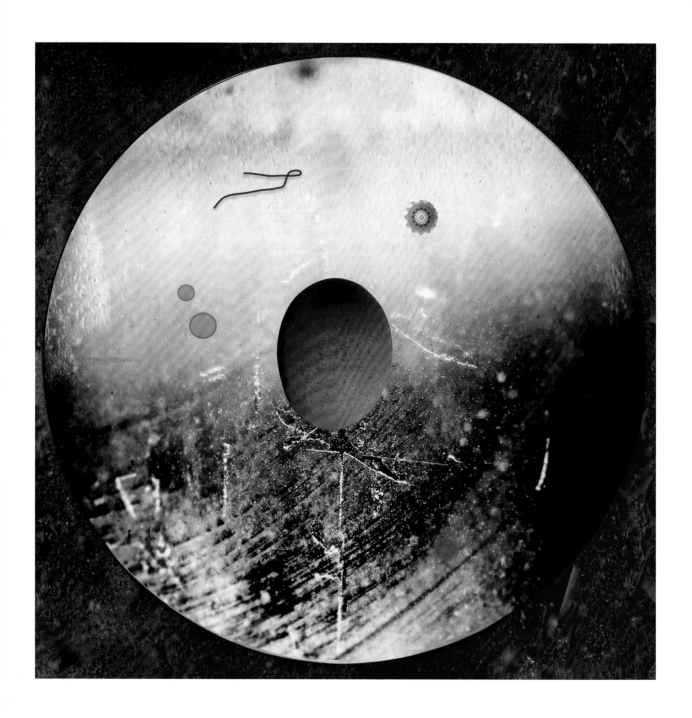

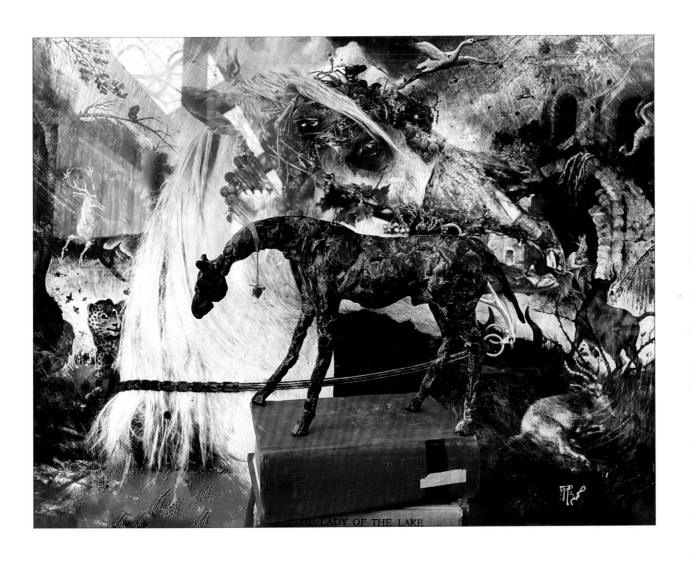

Without Don Quixote, weary Rocinante wandered through broken dreams of glory and tail ends of nightmares until he remembered his master had given him a gold necklace with a nick of his valiant heart attached. So, Rocinante began his own quest and discovered light in himself.

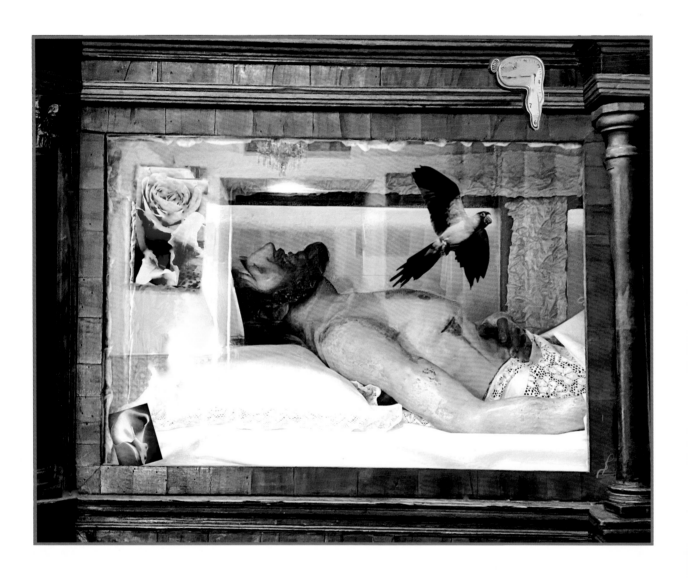

All he ever wanted was for people to be nice to each other.

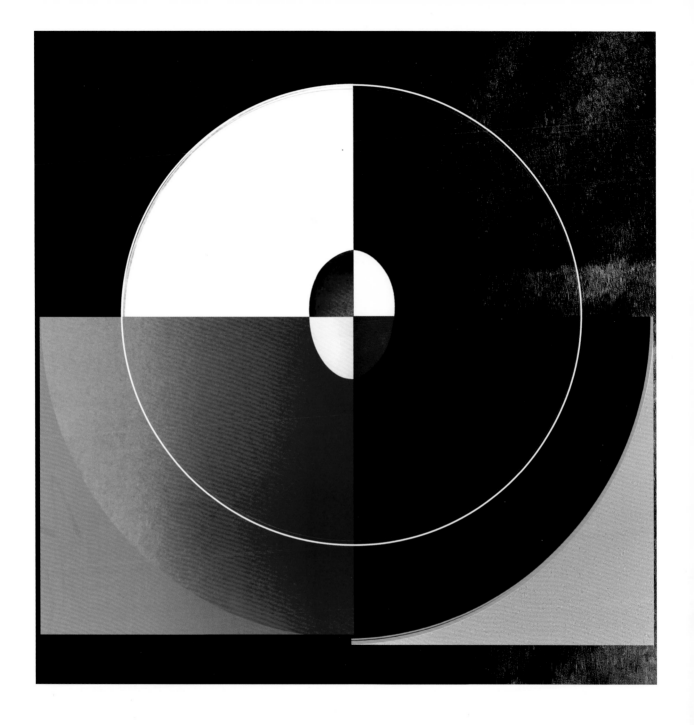

Nature takes on beauty, fragmentation, form, color, high notes, and low notes like a cosmic acrobat.

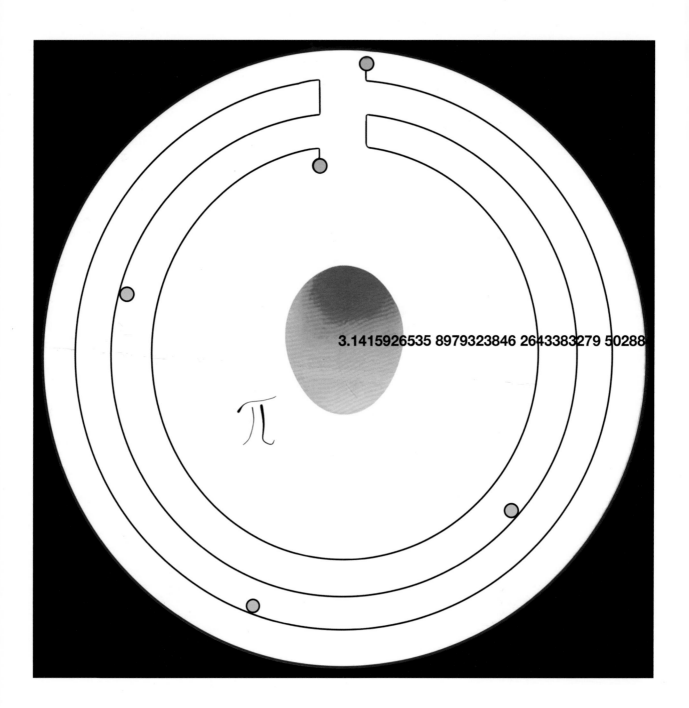

3.1415926535 8979323846 2643383279 50288

16

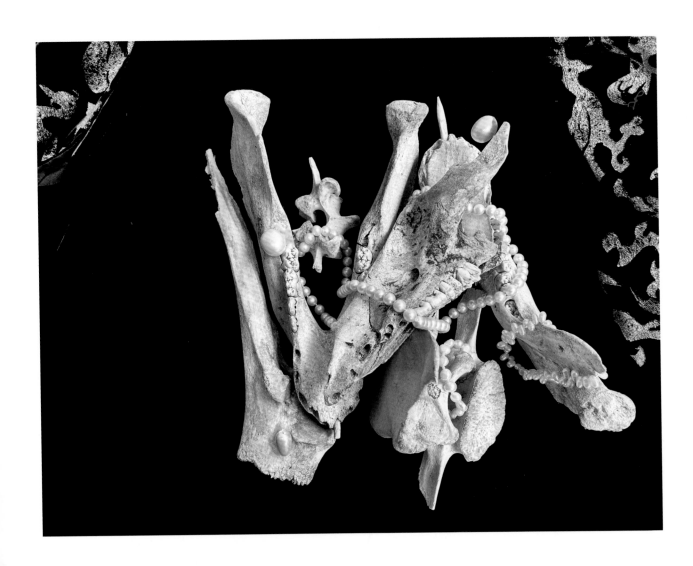

Everything is the face of infinity.

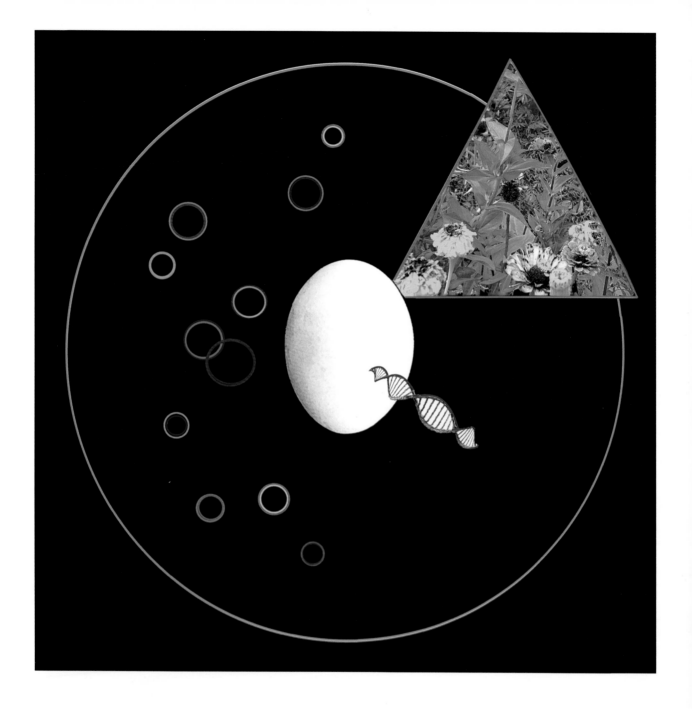

Light escaped darkness by splitting itself into spectra, streaming through cracks and creating flowers.

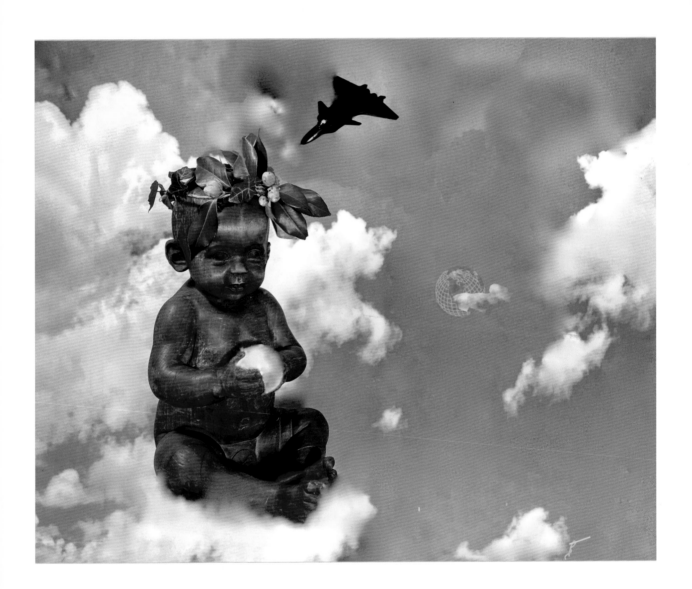

I

Perhaps God is the motherless child
lifted to safety over accordion wire
by a stranger who knew her family
before the bomb.

II

I dreamt of seeking shelter
from fighting in the street
through a circular door
down stone stairs
to a room barren of all
except a naked man lying
without arms or legs
on a narrow raised board.

Who are you? I asked.
How had he survived?

"I am God, I survive,
but depend on you
to do the work."

Whether this is true,
or not, I do not know,
and the dream was years ago,
but doesn't it make sense?

III

If the cosmos expands infinitely
in every direction—and we know it does—
surely love can also.

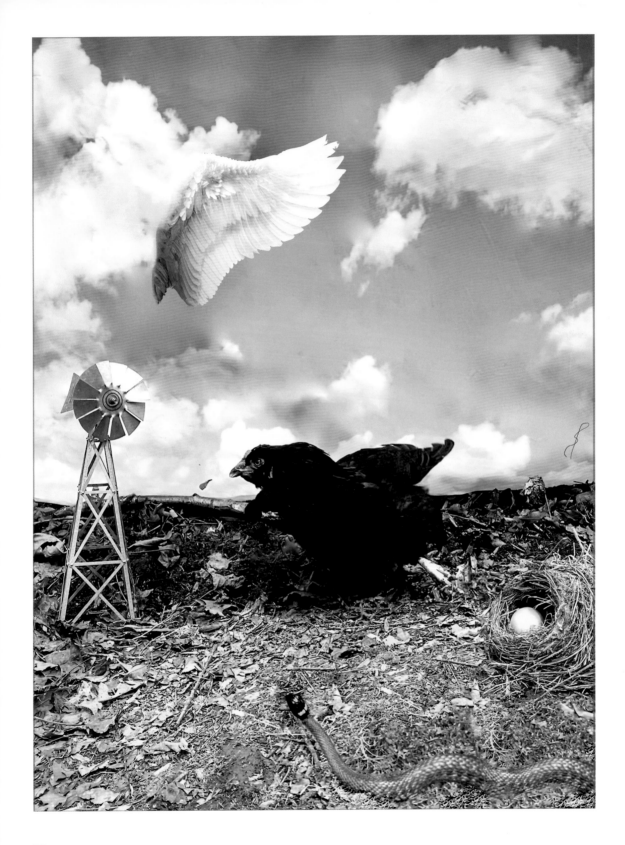

Silly hen! When demons threaten you, go higher. Demons are blind when they look up.

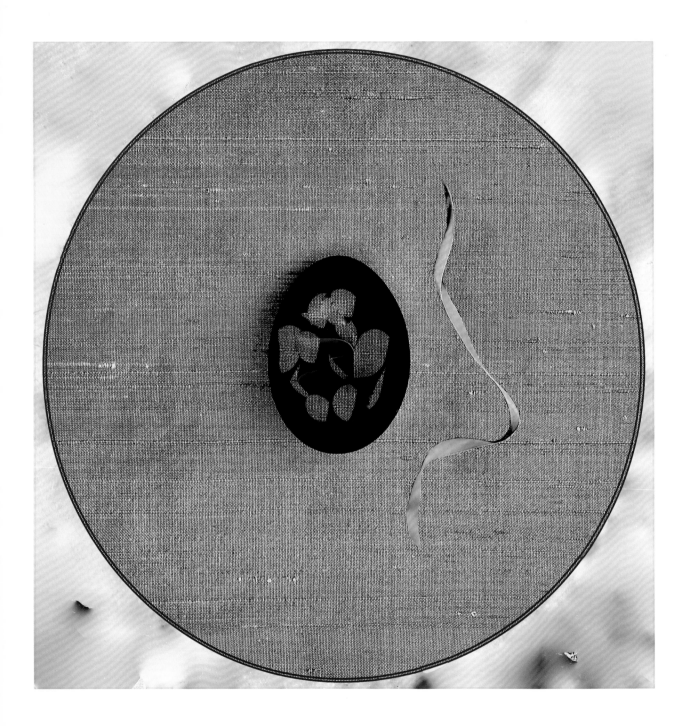

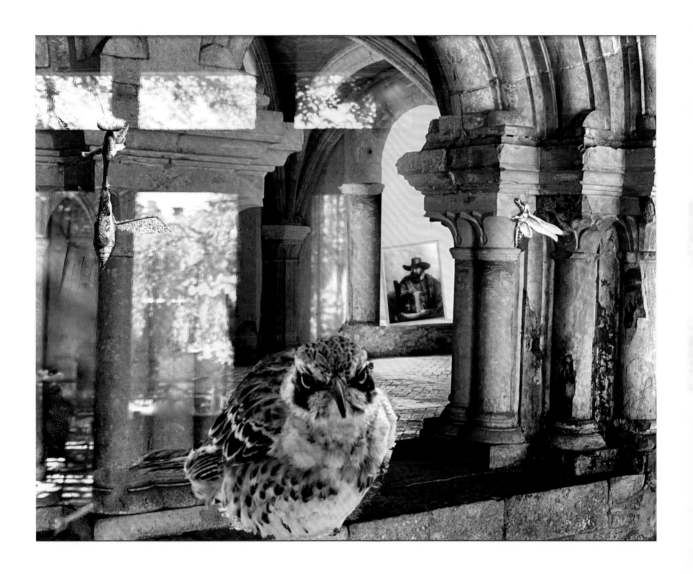

How dare you come to your House of Ancient Memories without bringing alms!

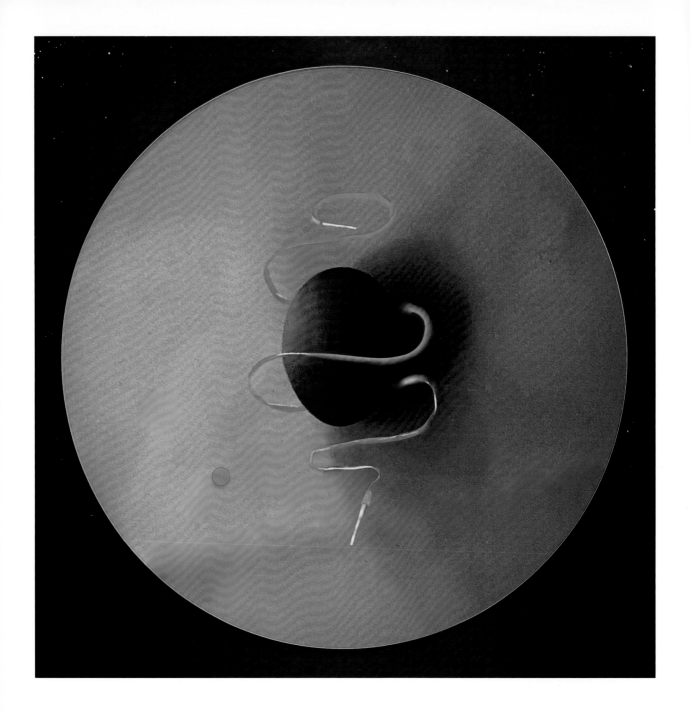

In the beginning was Concept, followed by creations of infinite varieties, even though time is an illusion. A golden thread twines around and around, infusing us, just beyond our grasp.

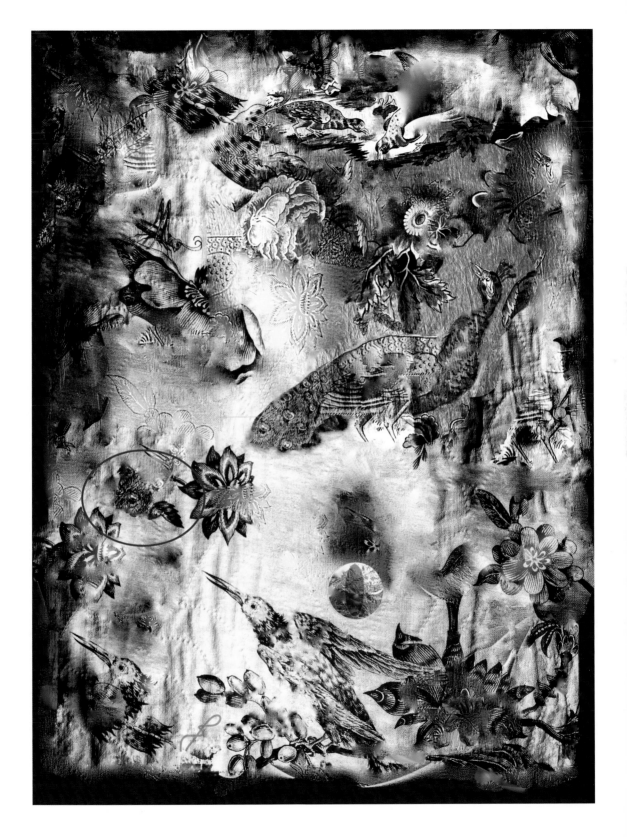

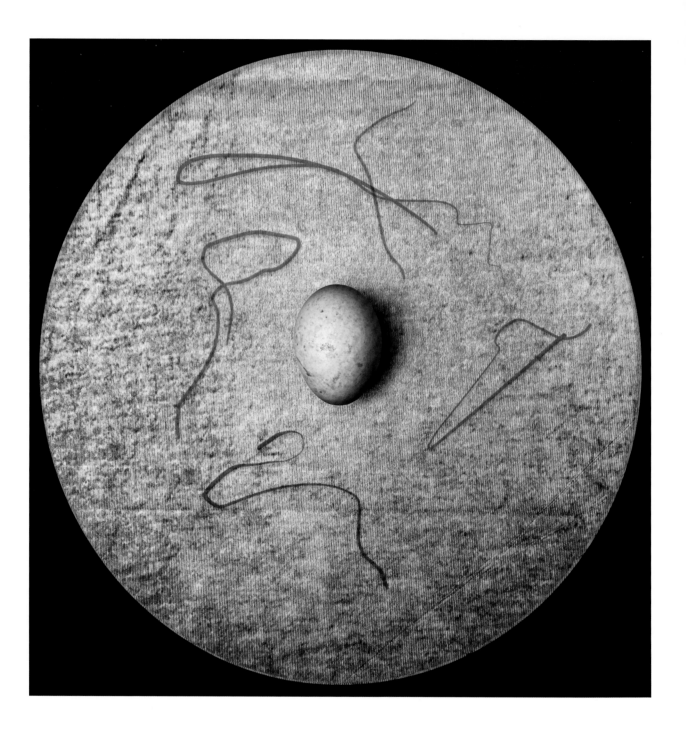

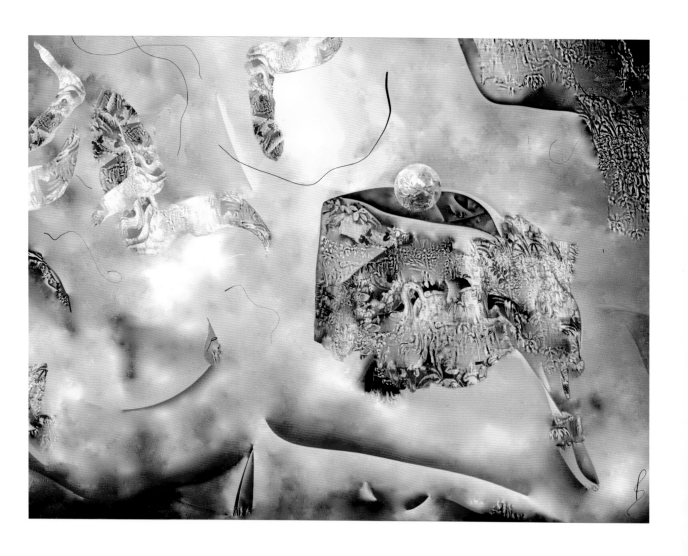

Threads hold ideas, clothing, and universes together.

I
Communication is movement—languages
 of curve, turn, bend, slide, glance—
 in speech, symbols, song, dance.

II
Hannah's world at the butcher's block
cleaving cows and pigs was silent—
her apron bloody, always bloody,
sinew, fat, tendon, bone.

Chop, wrap up, hand over meat.

The little girl said something.

 What? What into my silence?

She pulled herself up head level
to the counter, asked if I understood,
then spoke gibberish again.

No, I said.

Her mother grabbed her to the street—
the girl stumbled.

III
Being yanked—

Don't you know Hannah is deaf?

 What is deaf?

*She can't hear, she tells what you are saying
by looking at your lips—*

which is how the three-year-old learned
her secret code could not be shared
with the one person she sensed would
understand her.

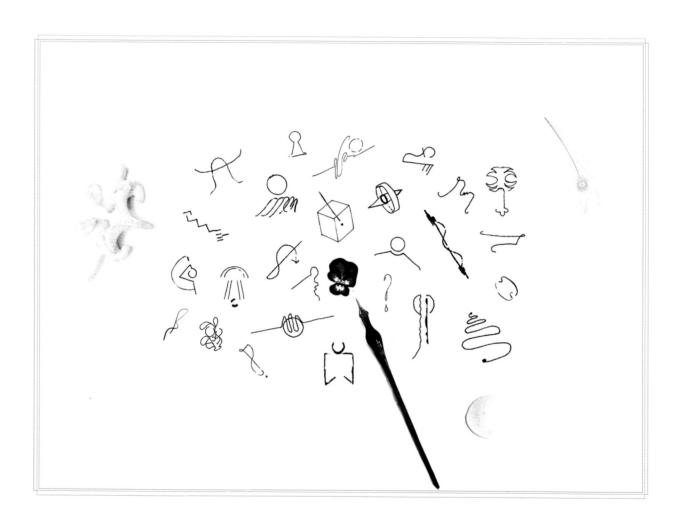

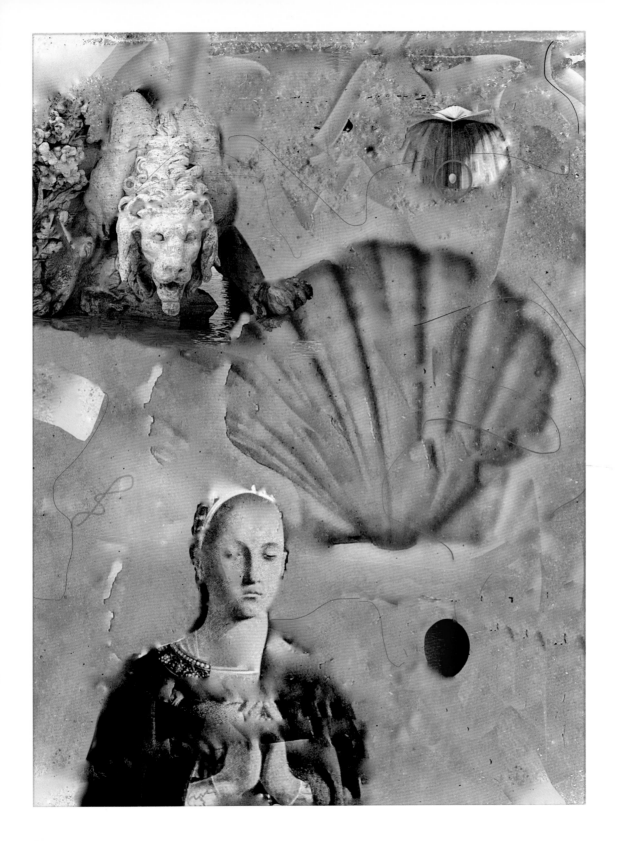

Rain in the night, tender as tendrils of honeysuckle, softens thorns of neglected dreams.

The girl looked at things askance, sensing whimsy can fling your brain around like a whirligig off its axis.

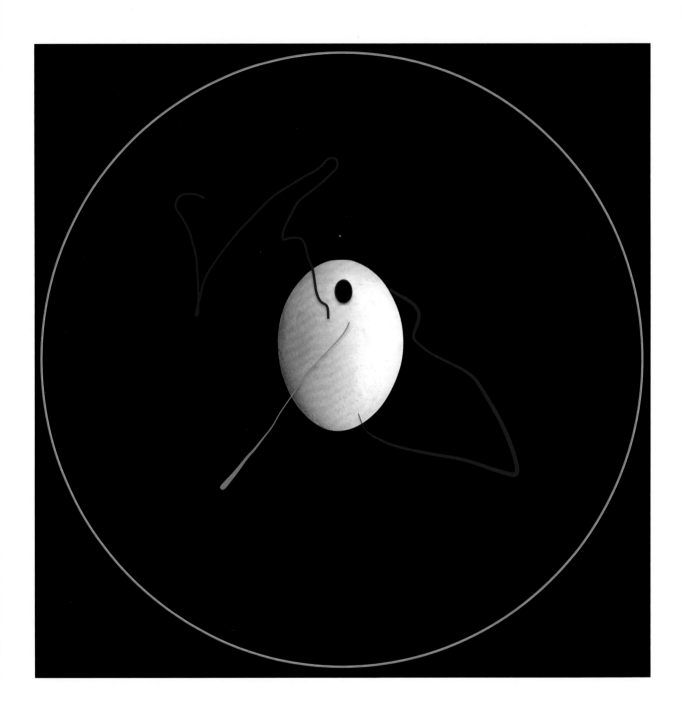

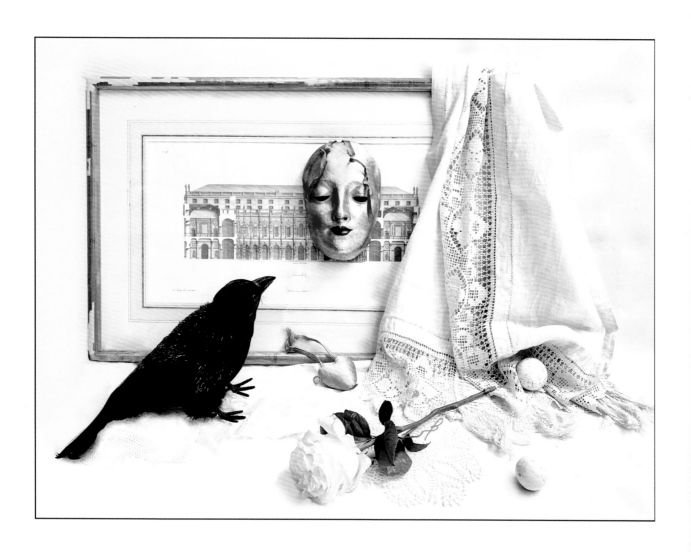

The raven brought her a white rose, golden ball, and his heart, but she remained distant, increasing his ardor. After all, he was only a raven while she had attended the infamous *bal masqué* of 1873 with Princess Asthenia.

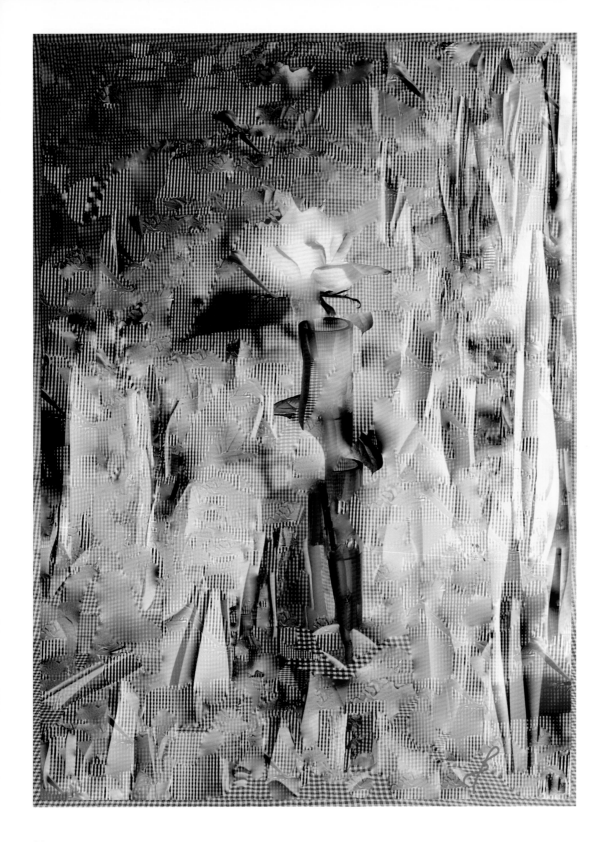

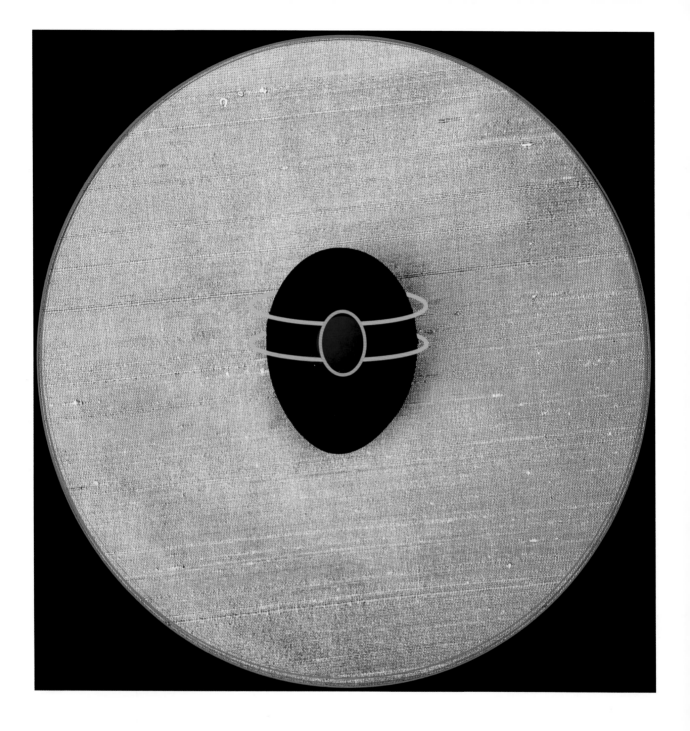

Her distant cousins—one white, one red—were emblems of a long mighty war. All she wanted was to become a tapestry of peace.

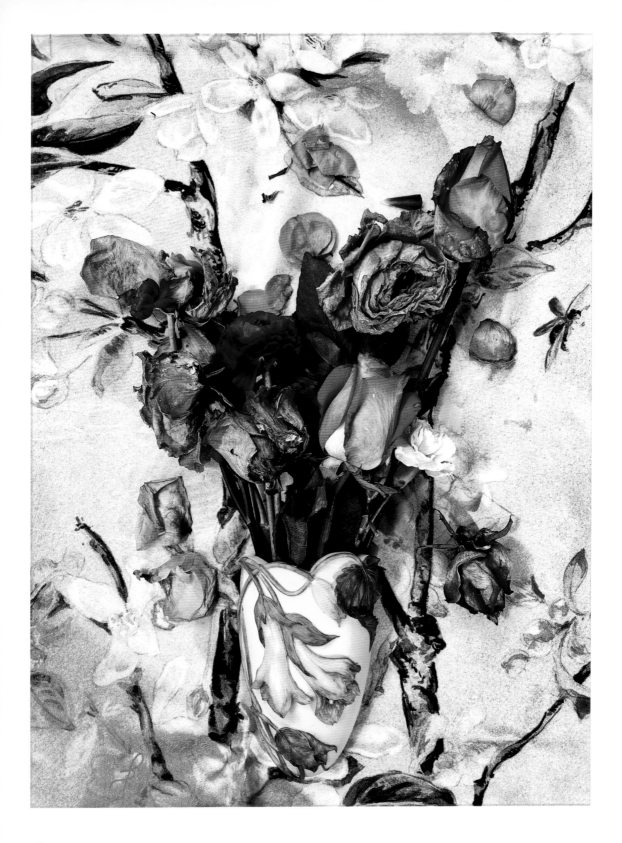

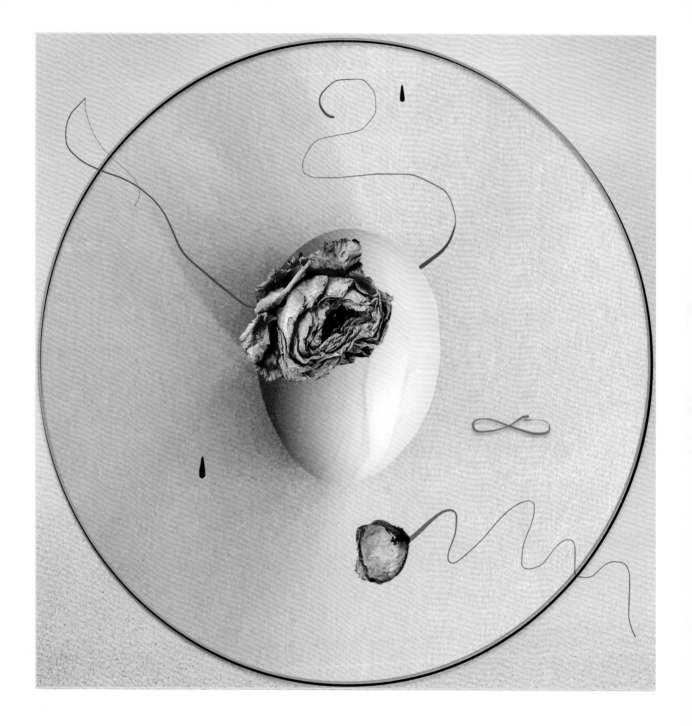

Roses cannot be remembered without smelling their perfume and feeling the cream of their early petals. Nature is a tease.

Which most beautiful—
feather, wing, bird?

Which most powerful—
drop of water bursting a seed,
ocean rising in anger?

Which most painful—
children in cages,
that you, like all, will die?

Which most startling—
mote of dust in sunbeam,
the insistence of light?

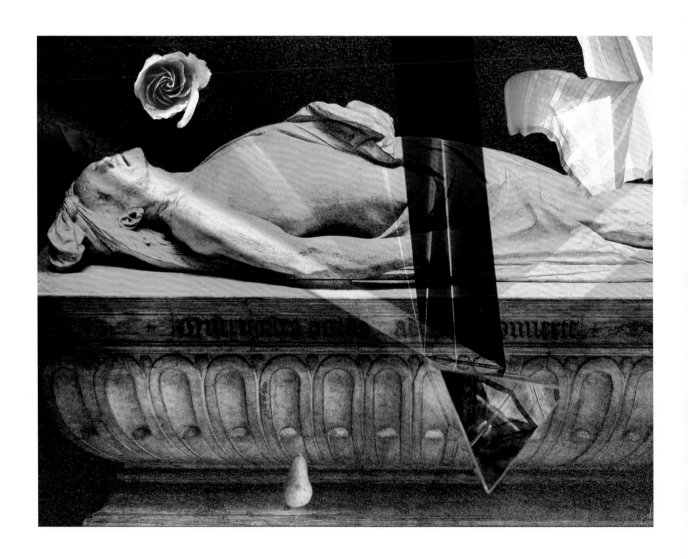

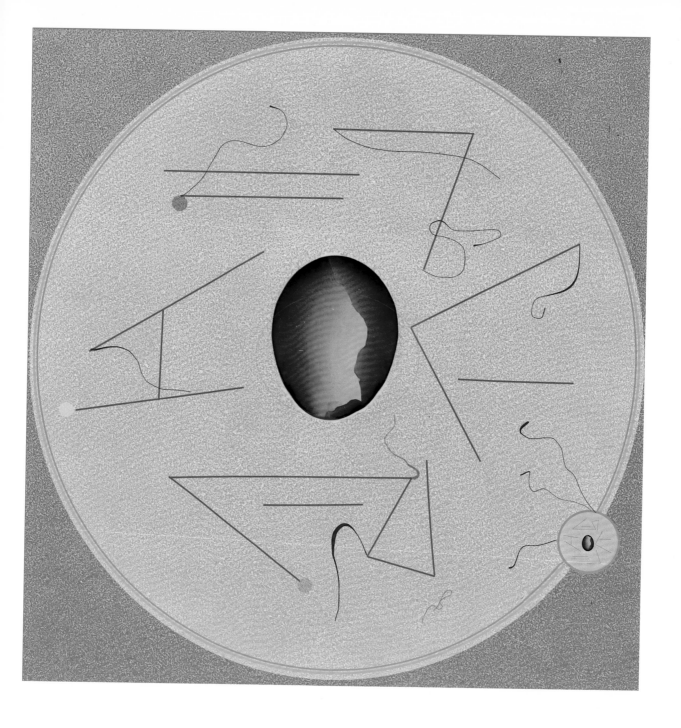

Wild, boundless, and uncatchable, the cosmos tosses off flowers like love notes. One would think they were the intention of creation from the beginning.

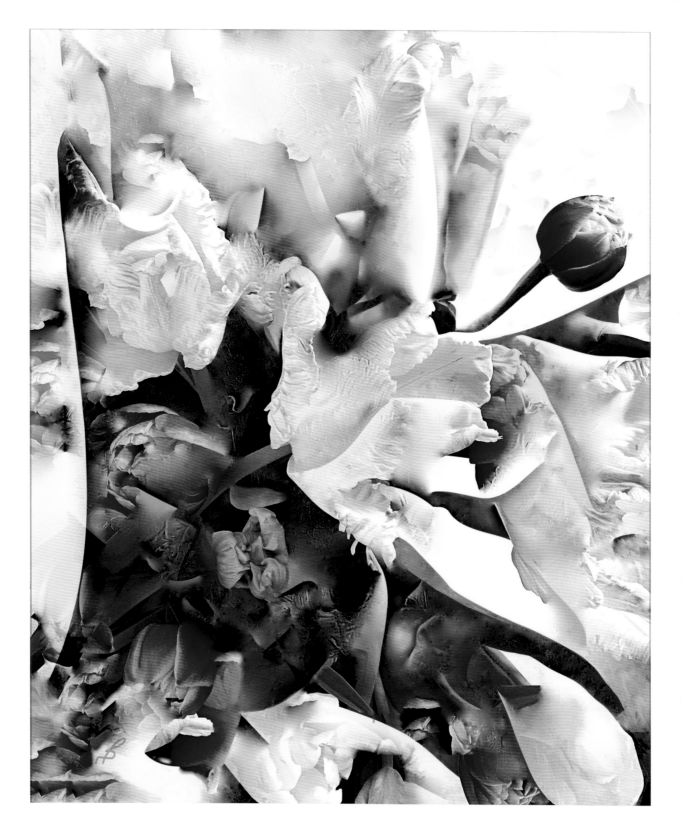

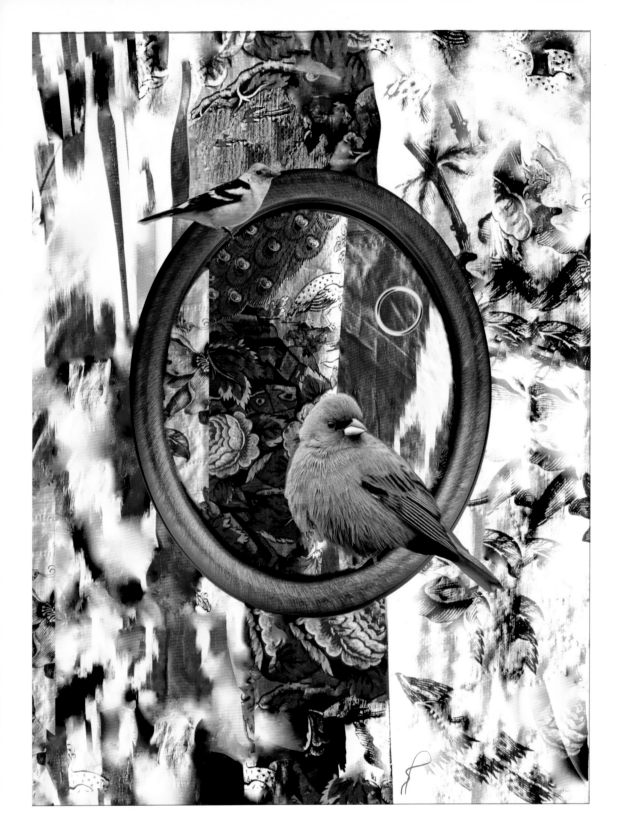

Birds assert they came first, laying eggs across pampas and waterlands, in nooks of barns, and under eaves, which proves birds can be vain since everyone knows the cosmos was birthed out of equations inside a red egg smaller than a rosebud.

I

Sisters Emily and Rose
were raised in the Christian manner
on a farm-like homestead
on the south end of New York,
recently New Amsterdam,
with a goat and roaming chickens.

On the third Sunday of May 1841,
Rose married Emily's beau,
whom Emily truly loved
and secretly called "Clarence dearest"
and for whom she had prepared
a secret hope chest of linens
and silk negligees.

When Rose became pregnant,
Emily made a crib quilt
bordered with French furnishing fabric
from Great-aunt Caroline's bag of remnants
left from bed curtains made in 1829.

Emily never gave the quilt to Rose
or her darling baby with blue eyes
and curly brown hair like Clarence's.

Decades later, It was found
at the bottom of her hope chest
in virgin condition.

II

The stories of fabric grand, painted,
humble, embossed, torn, fringed,
soiled, savored, shared, saved,
threadbare are stories of endurance,
survival, frivolity, opulence, dreams,
loss, pretense, ownership, industry,
invention, hardship, heartbreak,
love-making, happiness—

reminders of what we otherwise
have no way to recall.

III

In 1916 Lyda Rose wore the black lace choker,
which enticed a man to marry her.

She then tendered it inside a rosewood box
for a life of boiling potatoes and tending house
for a husband and six children.

Eventually, it came to her grand-daughter
who takes photographs.

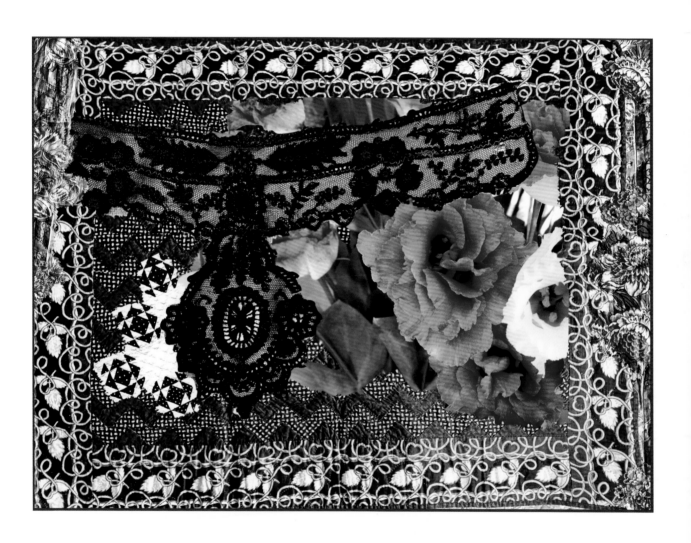

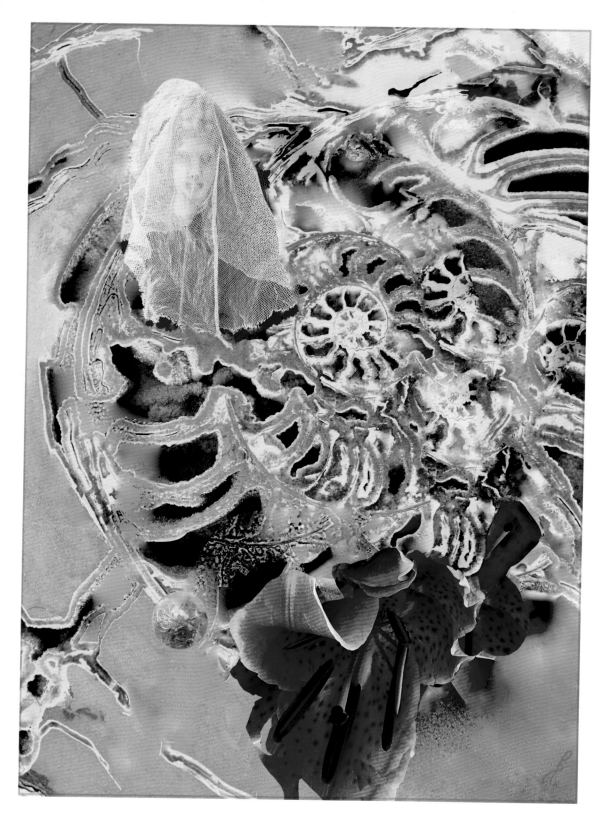

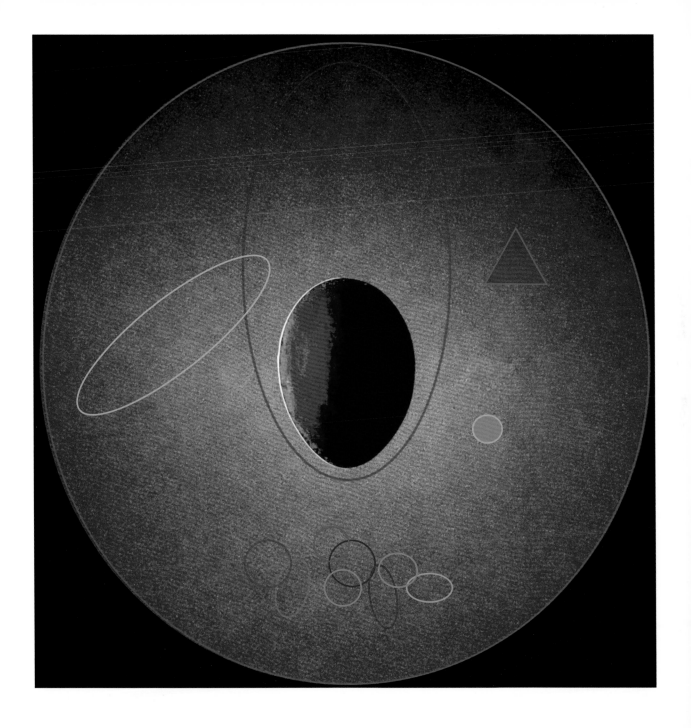

Beauty can be spare, wild, tamed, or generous, but it cannot be overdone.

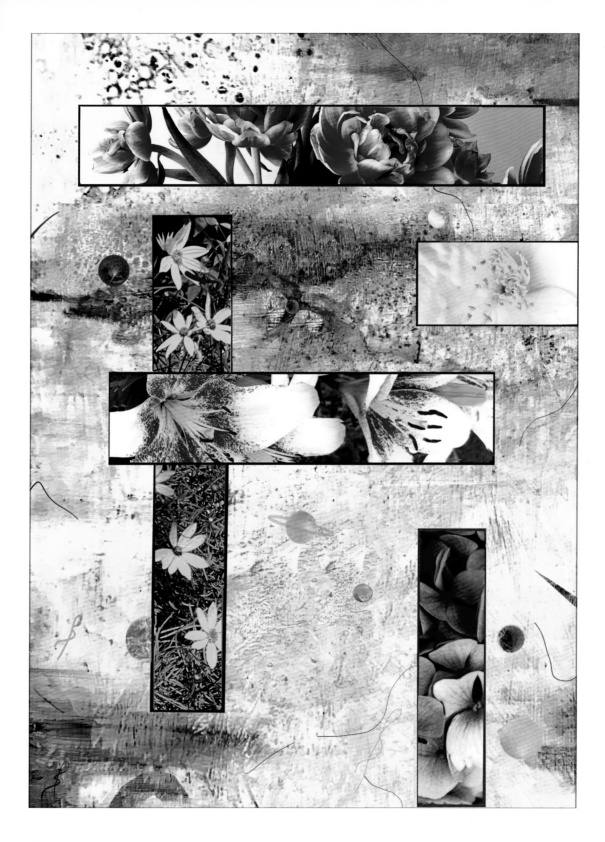

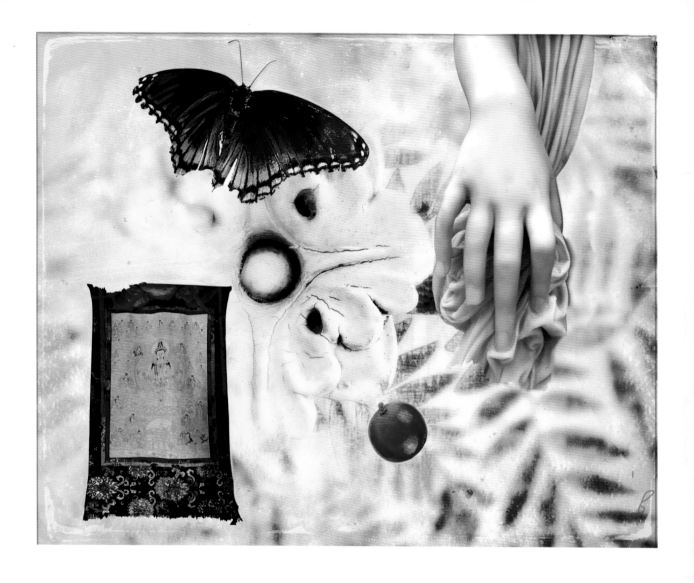

Phenomena lie on the surface of the ephemeral. The specific is born of the cosmos.

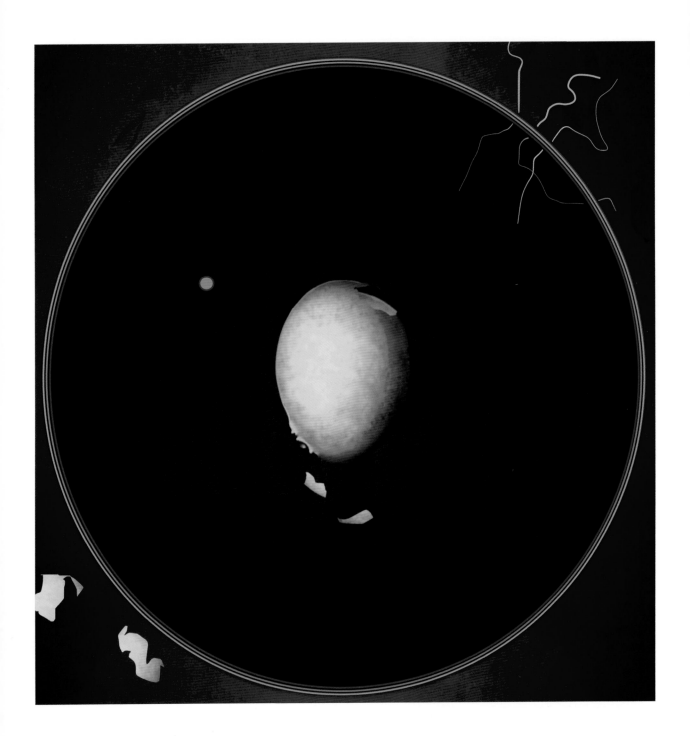

I

She placed a notepad and pencil
by her bed and asked God
to write His name in capital letters,
which was how she wrote
so assumed God did too
—capital letters an inch high.

Weeks passed before she realized
He could not leave evidence
He favored her—though
they both knew He did.

She asked Him to leave only a mark.
She was four years old.

II

She was wearing her patent leather shoes
and sitting in the fifth pew of the country church
with a blond Christ when Spirit surged
through her body shoulder to toe, urgent,
unmistakable, claiming her as His own.

When the tingling broke into hives
from the lanolin oil she applied after her bath,
she told no one. She was ten.

III

There are no words for knowing,
so I will not attempt, but nothing
has been the same since.

How could there be when everything,
including myself, dissolved and was known
beyond time, space, and physicality
as one whole, so no words
—addicts to divisions—could hold it?

Such small capsules we are,
but we have purpose and meaning,
and must try to live up to it.

IV

Across the meadow she entered a briar patch
of rusted wire, wild berries, rhubarb, asparagus.

The house had never been painted, poor
from the start.

The gap between the stairs and front door
was perfect for snakes. She knew, but jumped—
then froze at a rustle from the floor above her.

 desperadoes hiding from the law?
 hobos needing rest?
 rabid animal?

She crossed the floor slow, a frightened girl
needing to know. She climbed the stairs
to see eternity staring at her through the eyes
of a white owl.

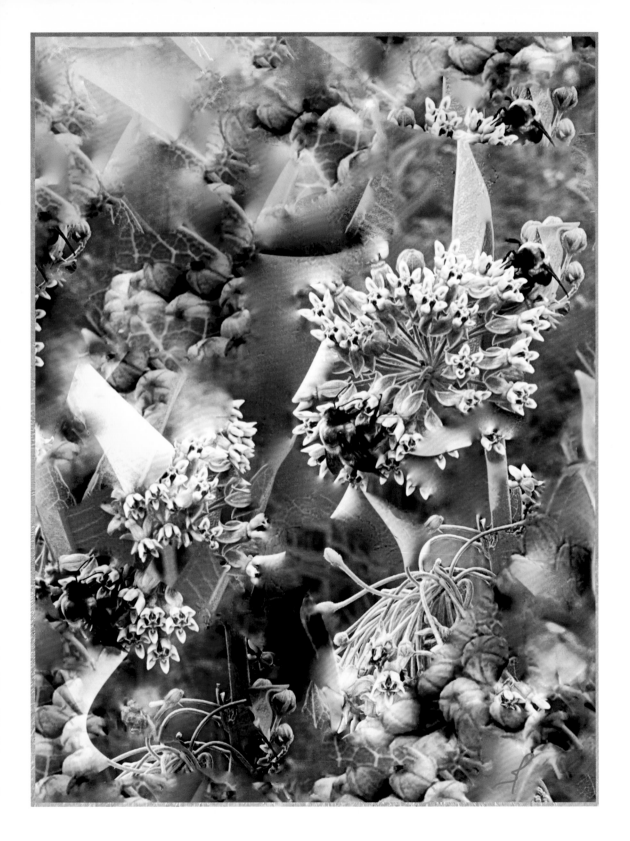

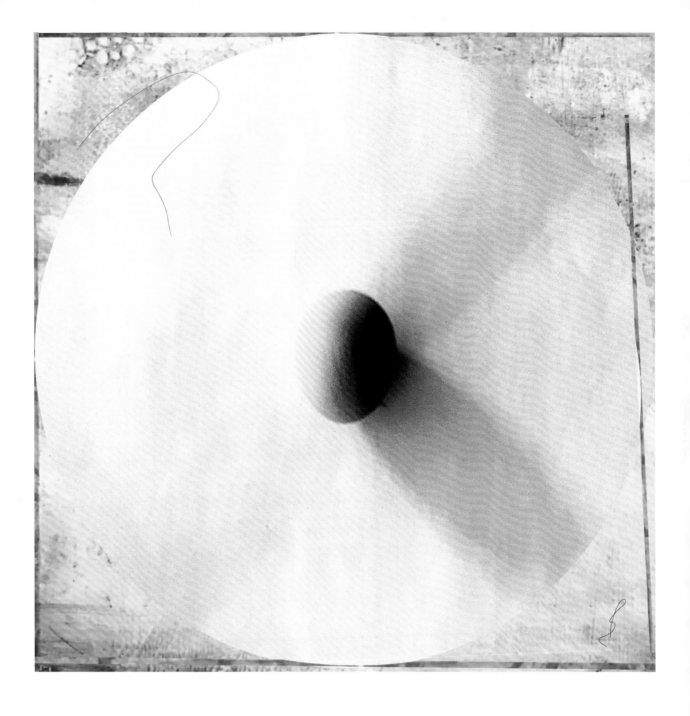

Buzz around, collect pollen, make honey, give directions with squiggly dances.

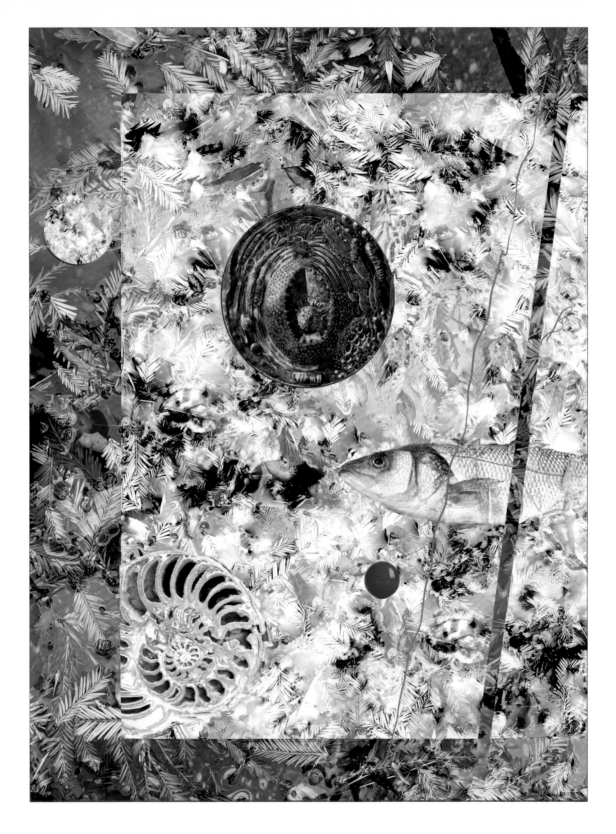

The Scottish mackerel was aghast he was filed with the queen conch shell, a red ball, and a fake photograph of a cell that went viral. He was real and no one ever noticed him.

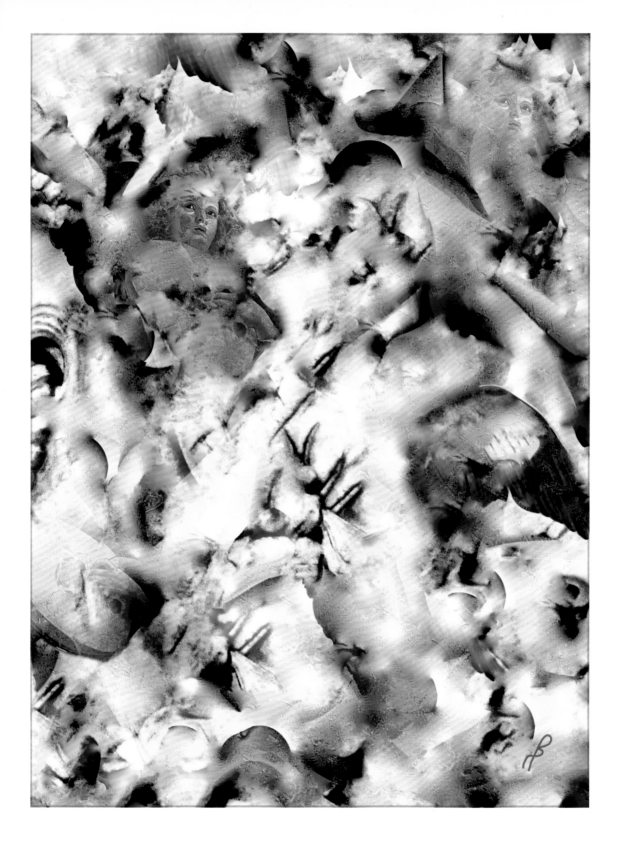

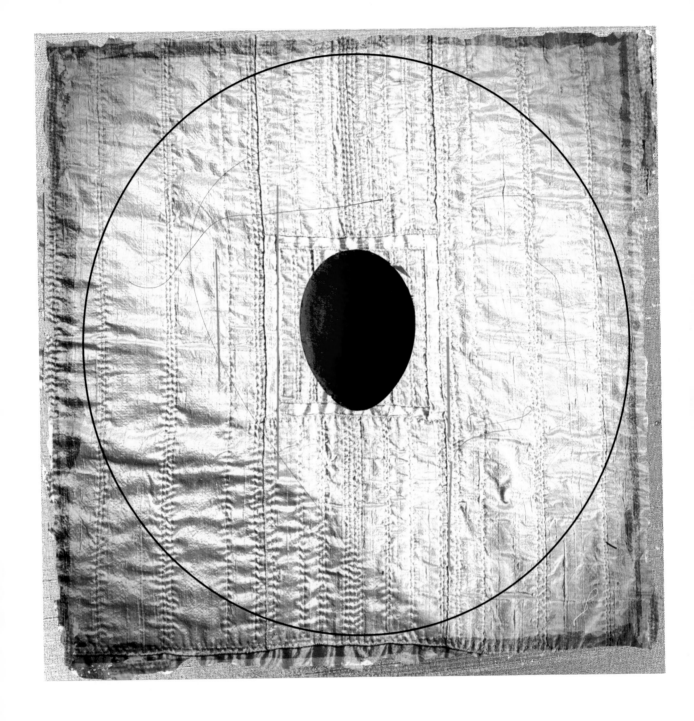

An angel played a lute, a wing spoke of flights across heaven, a golden apple reminisced of being coveted by gods. "Tell me more," said an old man wandering toward the end.

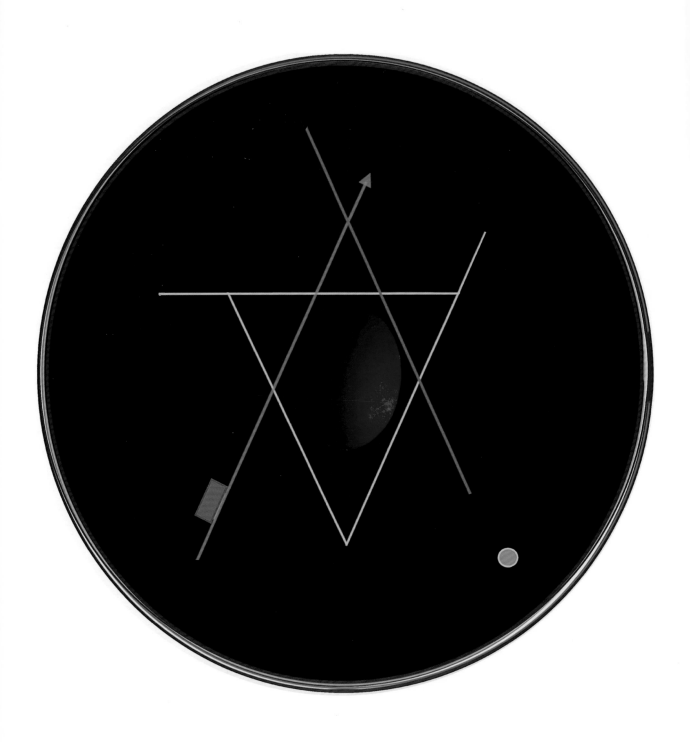

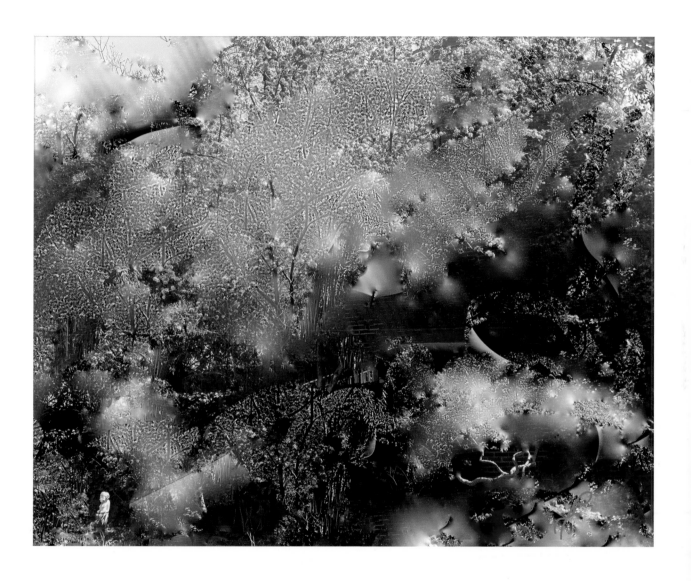

When the purple egg of the dark cosmos opens, gardens appear, symphonies are composed, and poems slipslide out of lovers' lips.

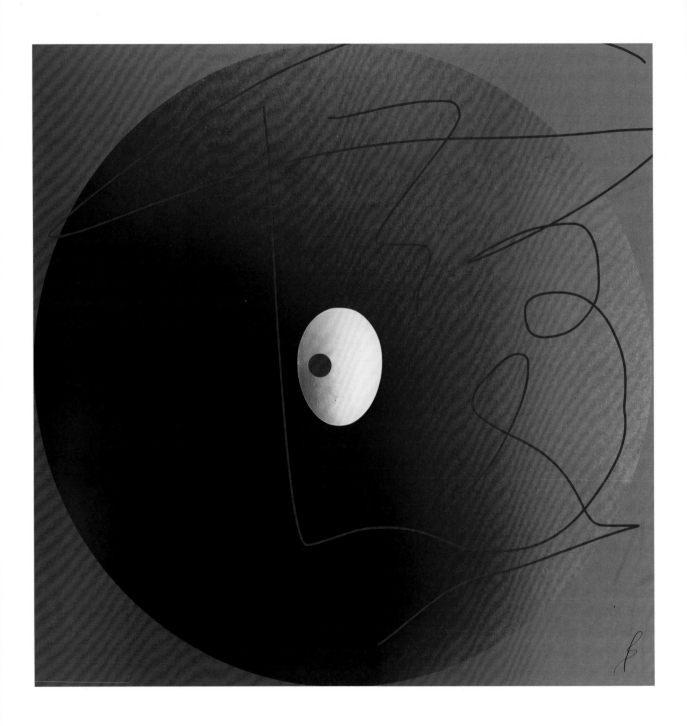

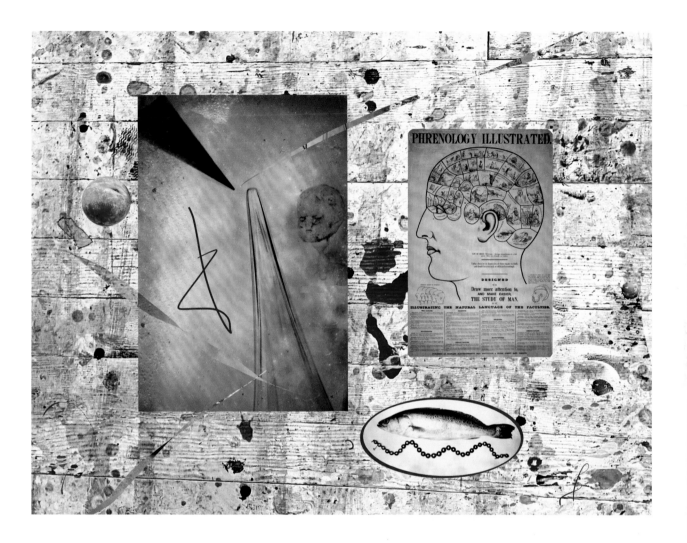

On the floor of the painter's studio lay the remnants and colors of his imagination.

I

not dust but silence
in the beginning and at the end—
the first evicting you into being,
the second welcoming you home
where knowledge is beyond words

II

beads fall off my necklace

hope
quartz
jade
envy
friends
lovers
pearls
beliefs
diamonds
tiger's eye
memories
amber
pain
ember

into ditches, garden beds,
the sea, mourning tears,
down sink drains and sofa crevices

leaving a thread of silence
and grace

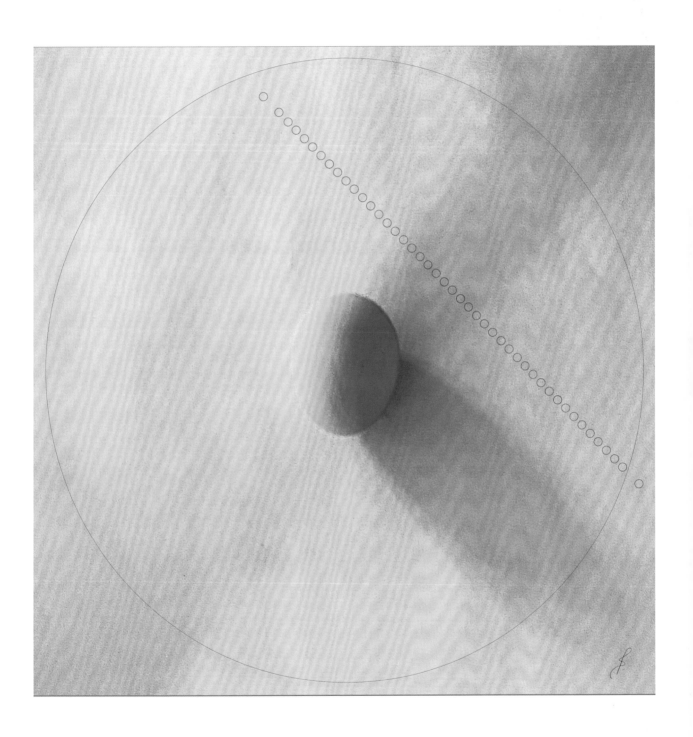

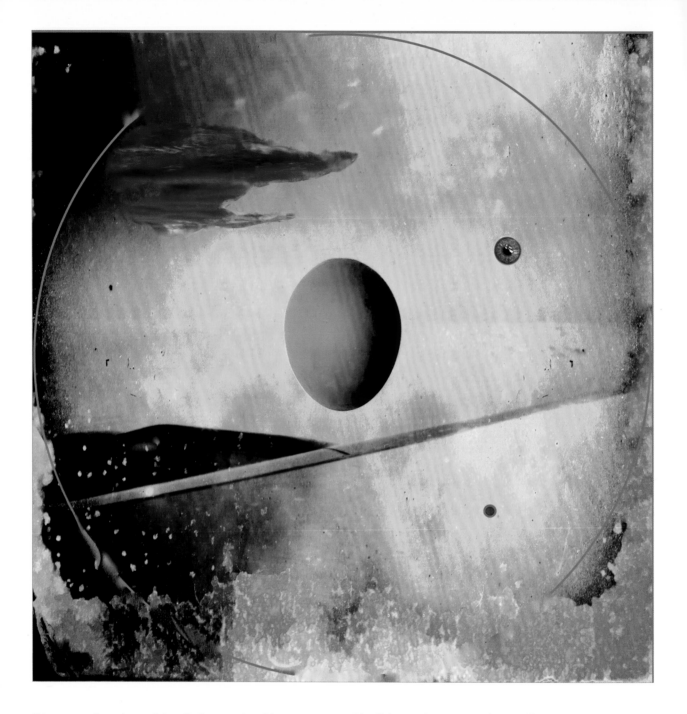

If I were a lion, I would split the earth with my roar, and half the universe, and myself, too, for I am of the earth.

The colors out my mouth would circle the earth and mate with orange of mango, blue of sea, red of blood, and sunset cloud.

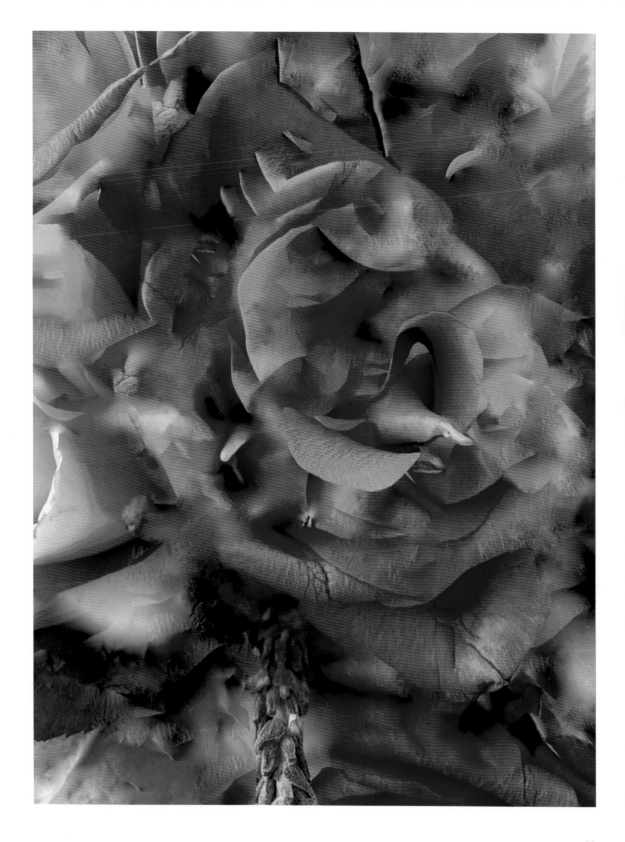

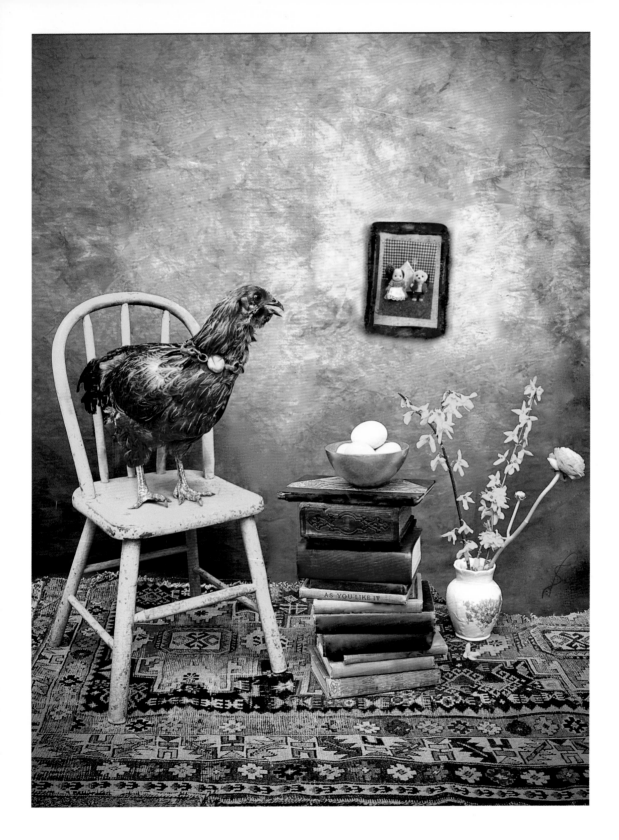

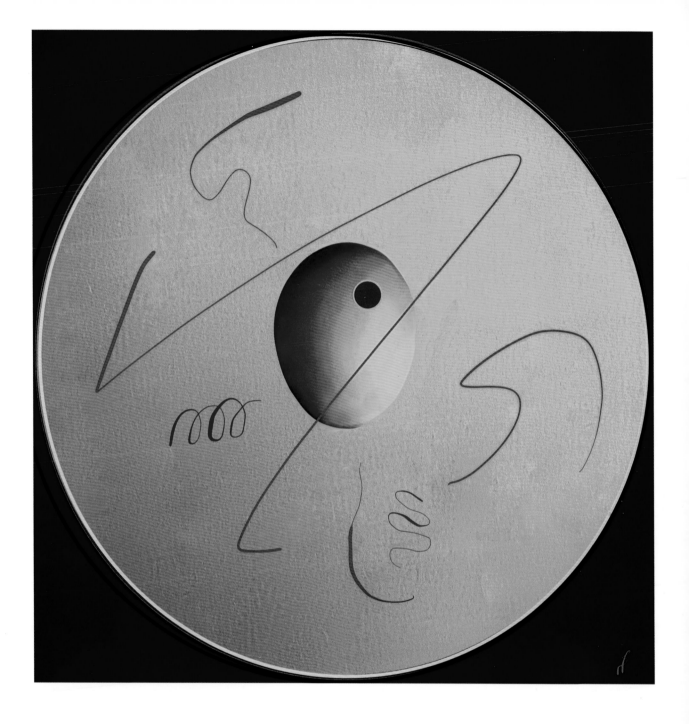

It was the best of times . . . cluck cluck . . . *and the worst of times . . .* cluck . . . *to be or not to be that is the question . . .* cackle, cackle . . . *alas, poor Yorick . . .* cluck

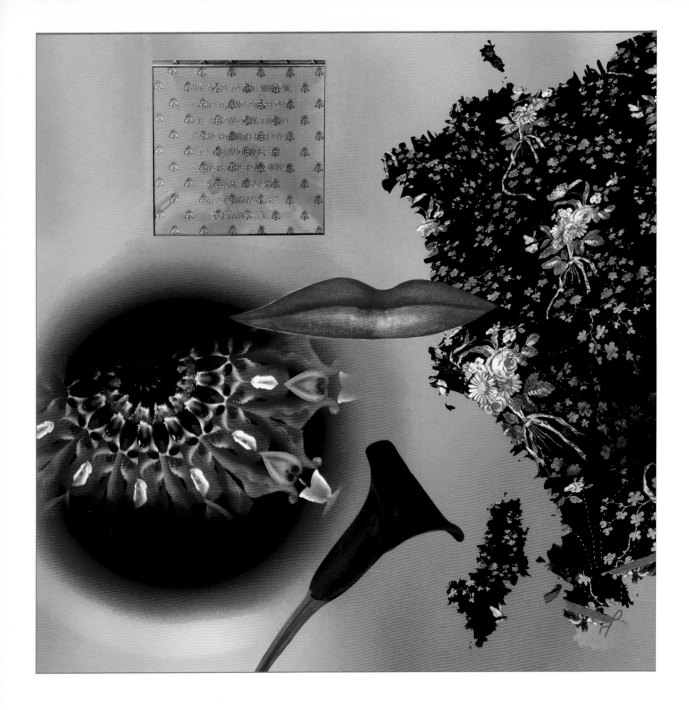

The lips tell it all.

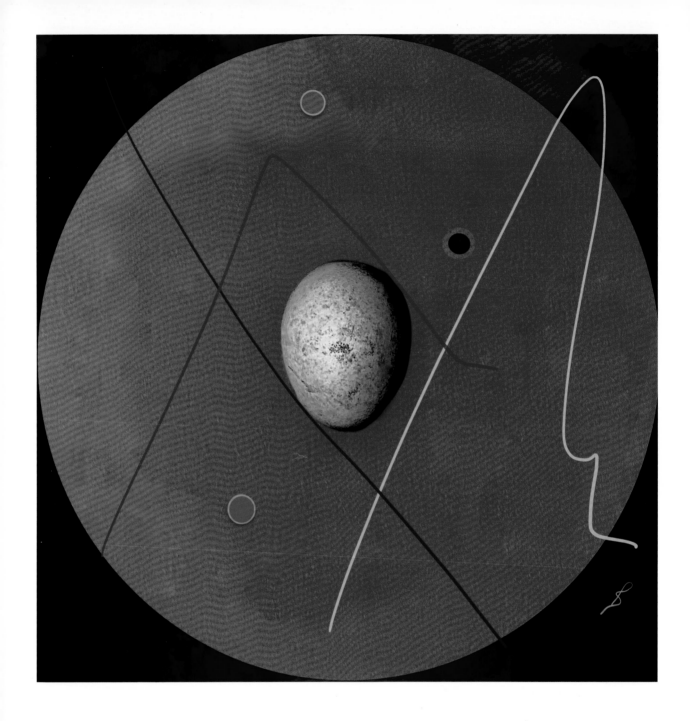

One day his lack of humor, or even irony, about their pretentious life made her snap. The meat cleaver was handy. A sense of humor is life-saving.

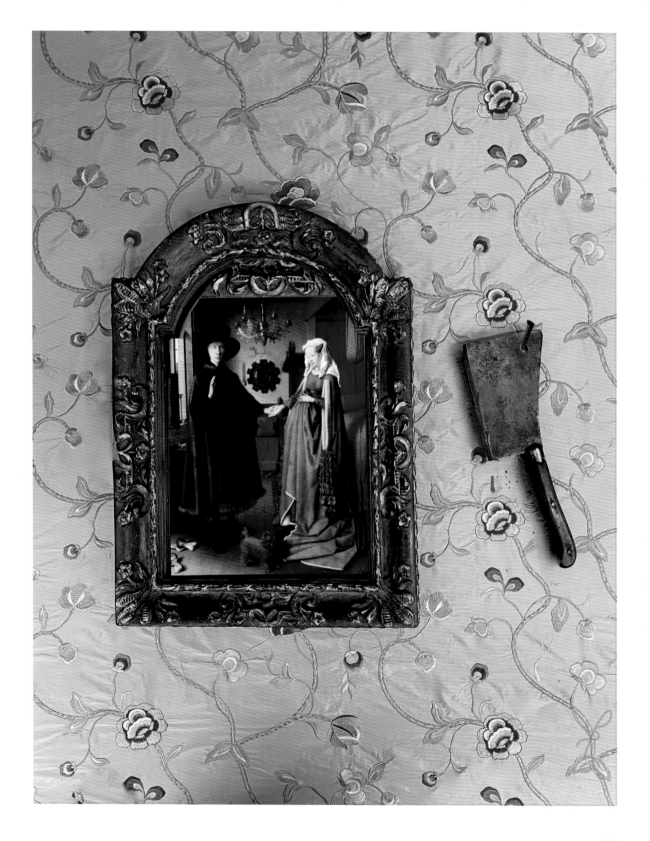

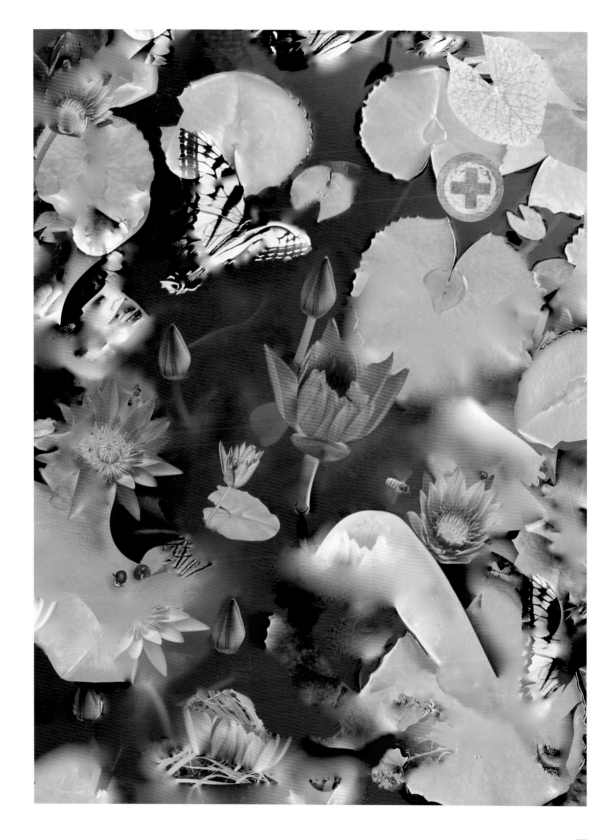

I
The girl, born in a snowstorm, cherishes the sun.
Considered an ugly baby, she became an expert on beauty.

Watcher of animals, seasons, plants, and silent parents,
she whirled in spring winds where no one could see her.

Heaven forbid her parents should see her!

The girl grew and left, claiming only the wind and soil,
clutching black loam to her breast like potential.

II
She returned to the front yard in the sunsuit
her mother knit for her. It was what her mother could do.

She returned with her hair up, wearing sandals,
sunglasses, and red mittens that had to do for gloves.

Her mother laughed.

III
Tsunamis, avalanches, volcanos, flood, earthquakes
occur often in the flatland of corn and pigs.

They just aren't as visible.

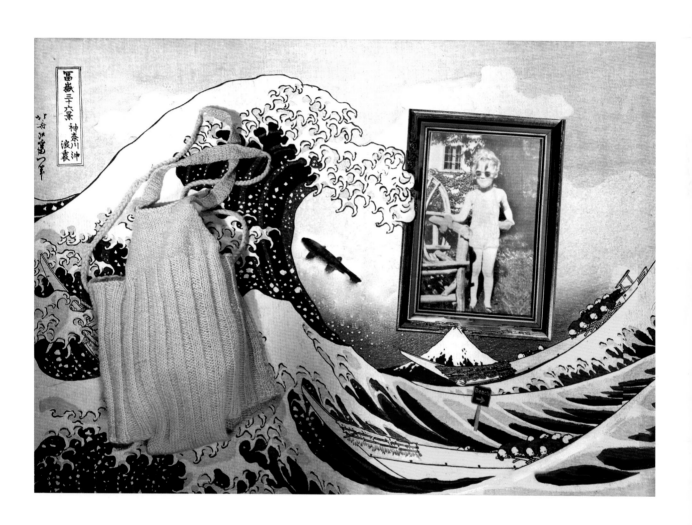

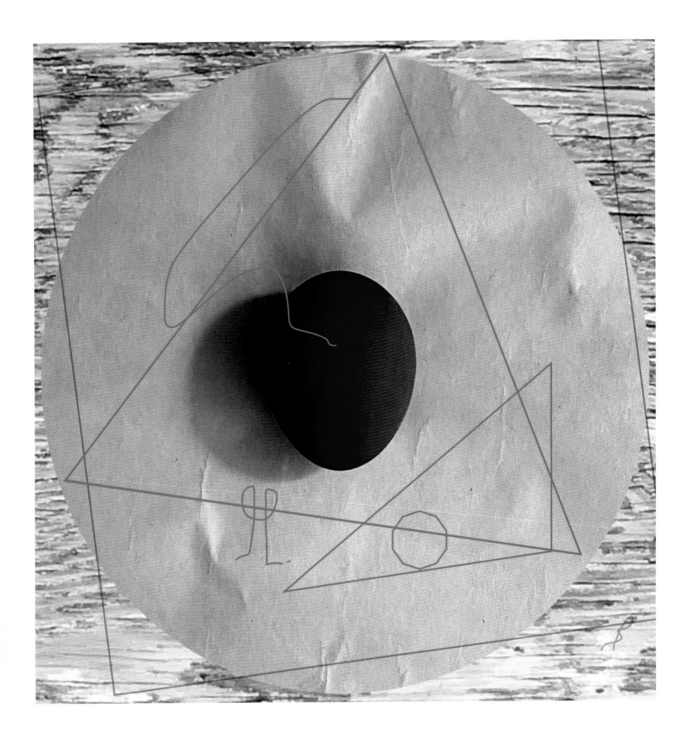

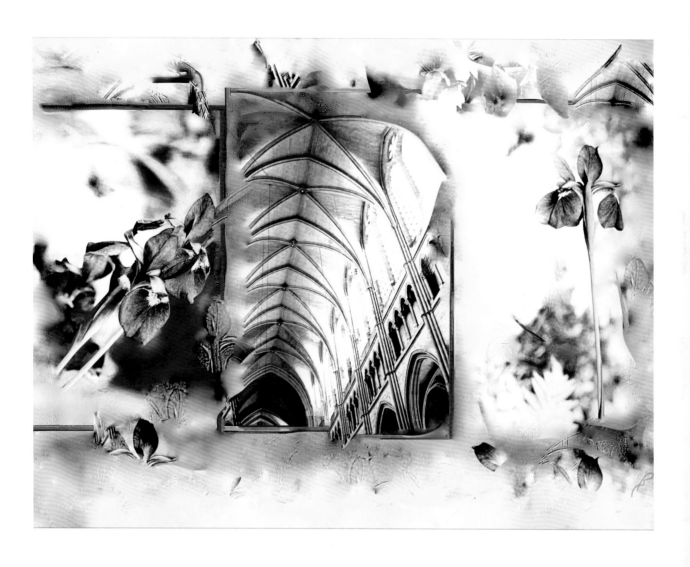

The triptych lifted up off the wall, carrying the roof of a French cathedral and clutches of Japanese iris.

I have never ridden on twilight
above the beach over the ocean
under brightening stars.

Still, I sat, cross-legged, on the shore
as the sun set beneath the horizon
of the Pacific

when all became pulsating plasma
of colors and shapes of a mighty heart.

 pump pump pump

A fly came to hover outside my gaping mouth.
I saw what it saw, a moist cavern of pink
and crannies. It, too, was delighted with the evening.

I did not dilute the knowing by telling anyone
until weeks later with a friend in a restaurant
in San Francisco.

Tears of rapture fell into my lasagna.

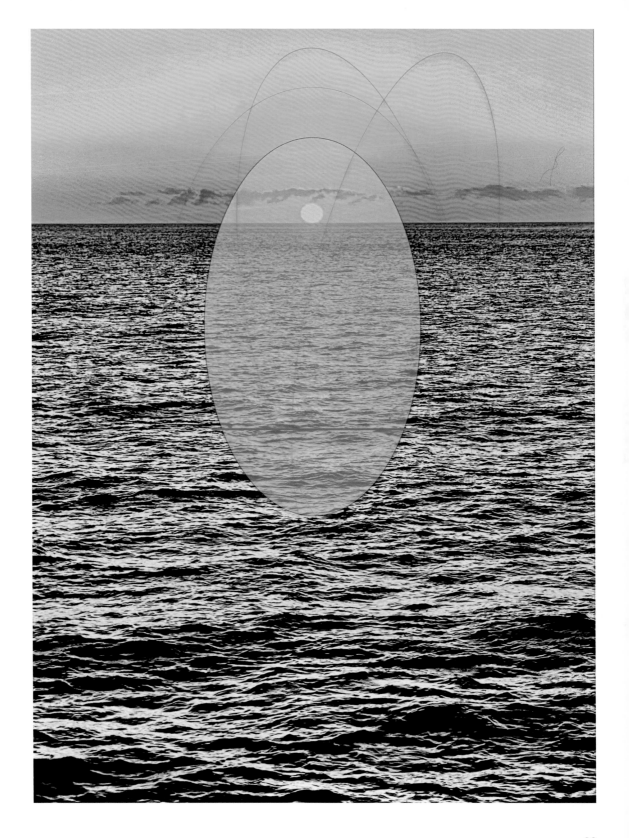

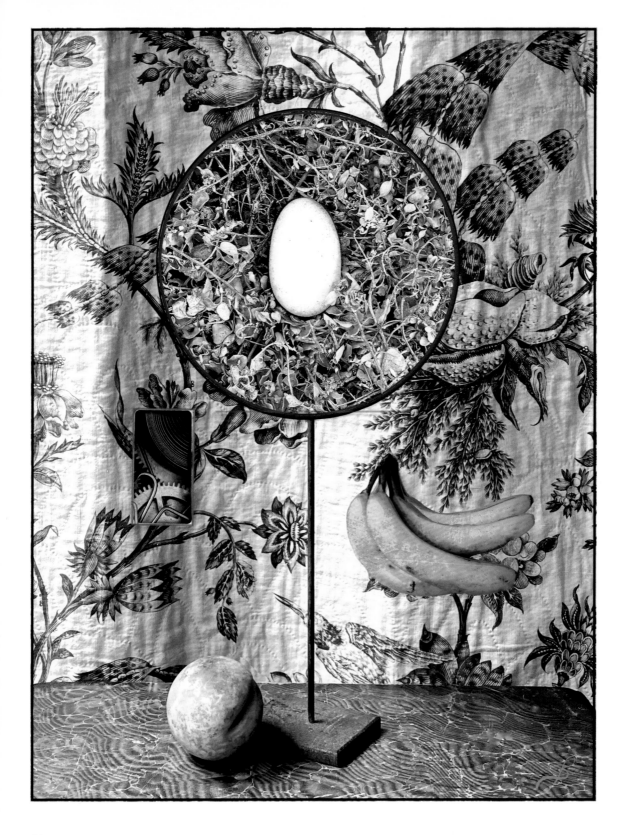

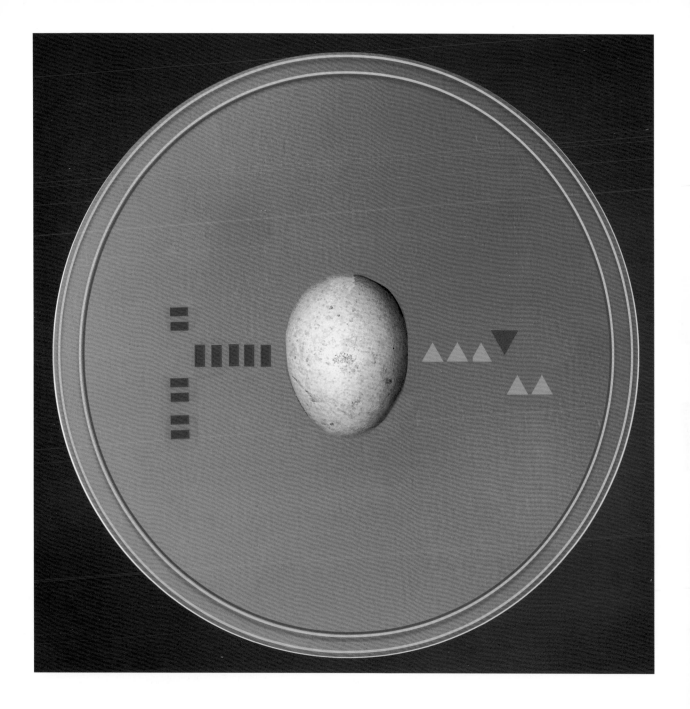

Albatross eggs are streamlined for comfort in a flying bird. Bananas can fly. Stone peaches were follies of eighteenth–century Parisians. One of these is not true.

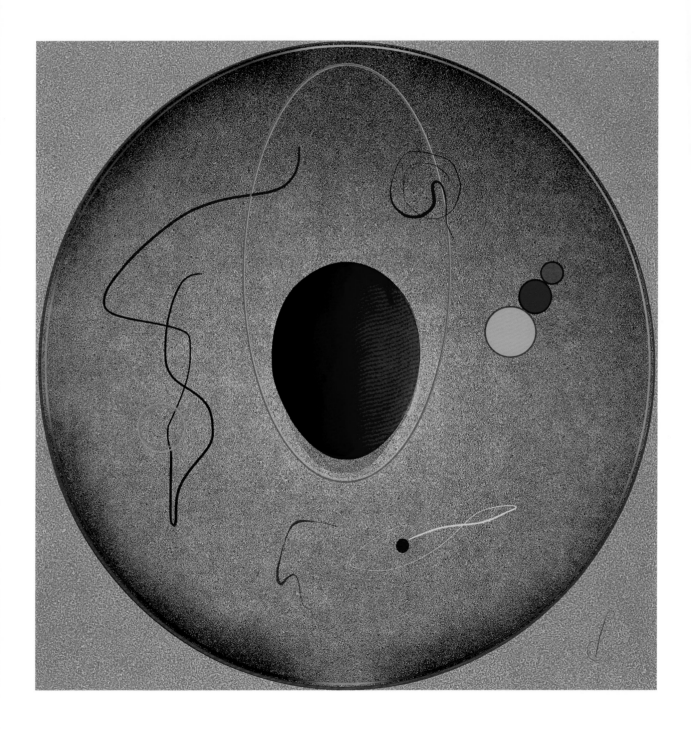

Heart Conditions

I showed you my secrets. Tell me no lies.

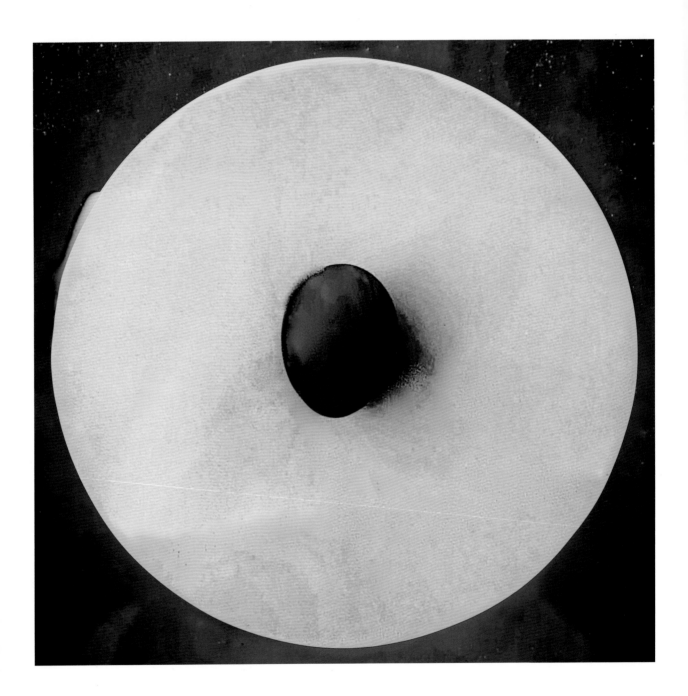

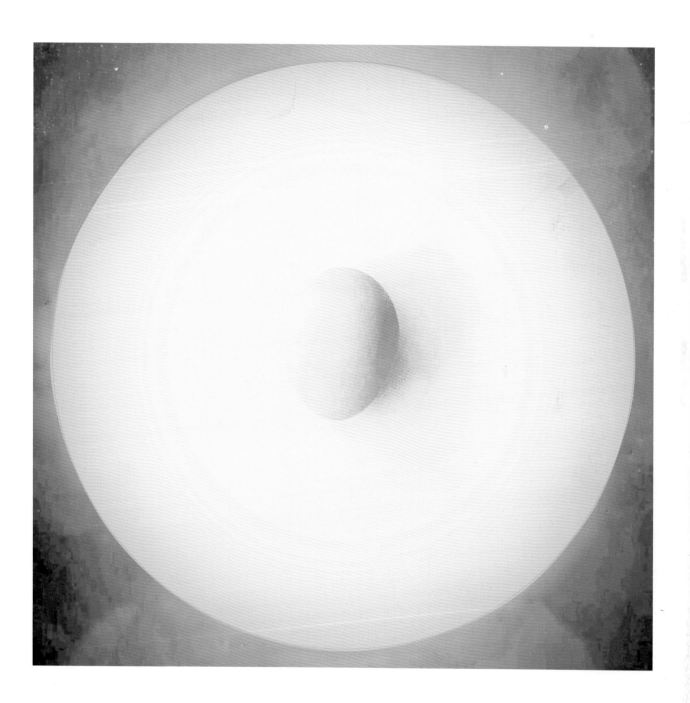

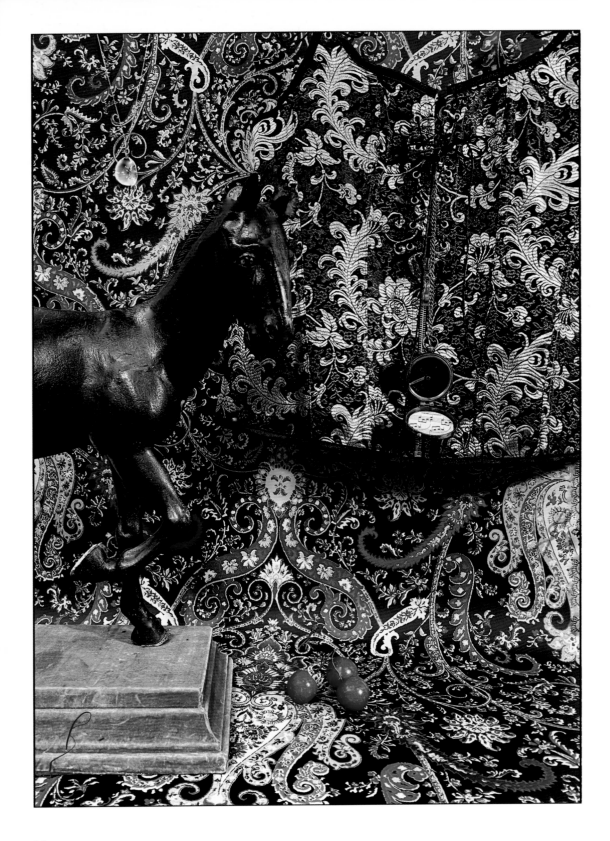

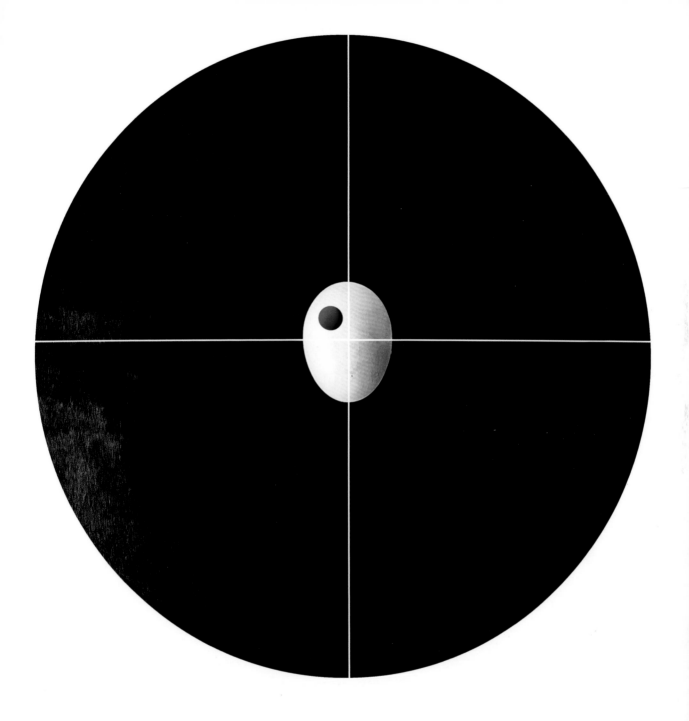

His dignity still intact the eighteenth-century Italian horse thinks often of his halcyon days as a young stud in the royal courts.

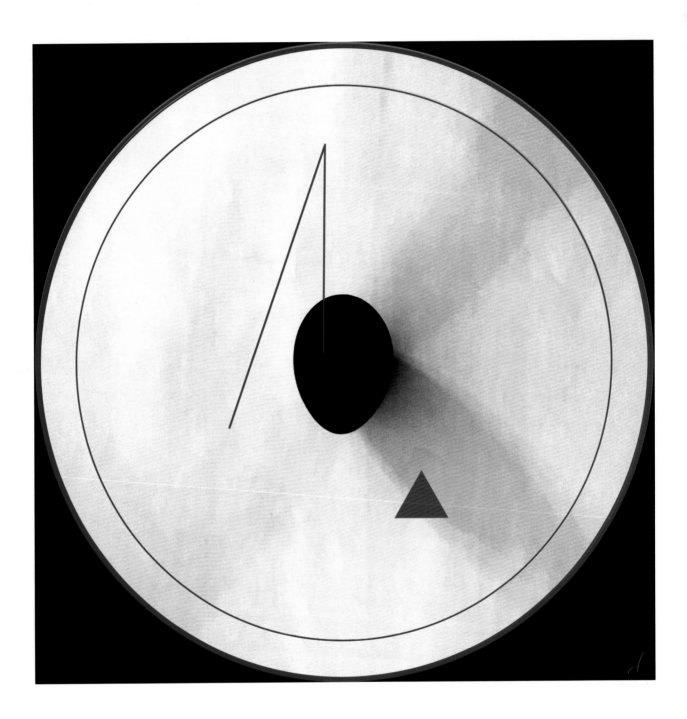

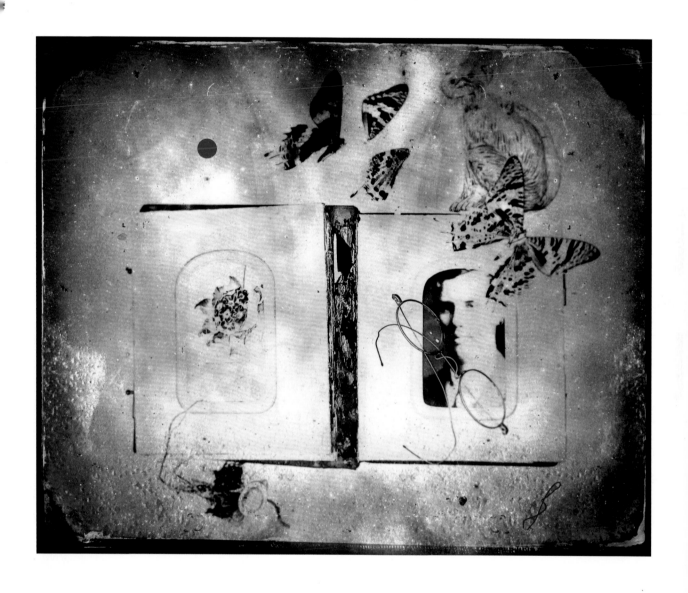

My father was a handsome man who told stories that hooked the other farmers like tines on a forklift.

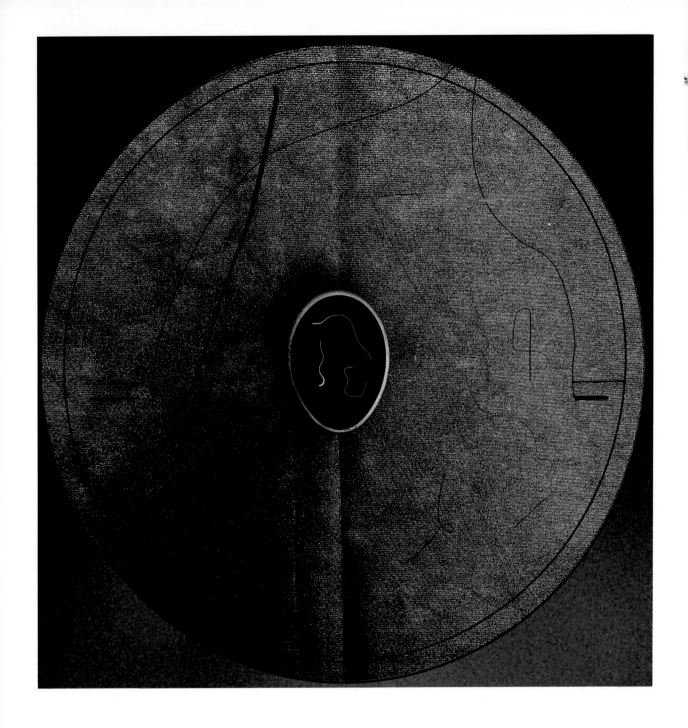

Pressure of the dark and deep creates diamonds and germinations rapturous for the light.

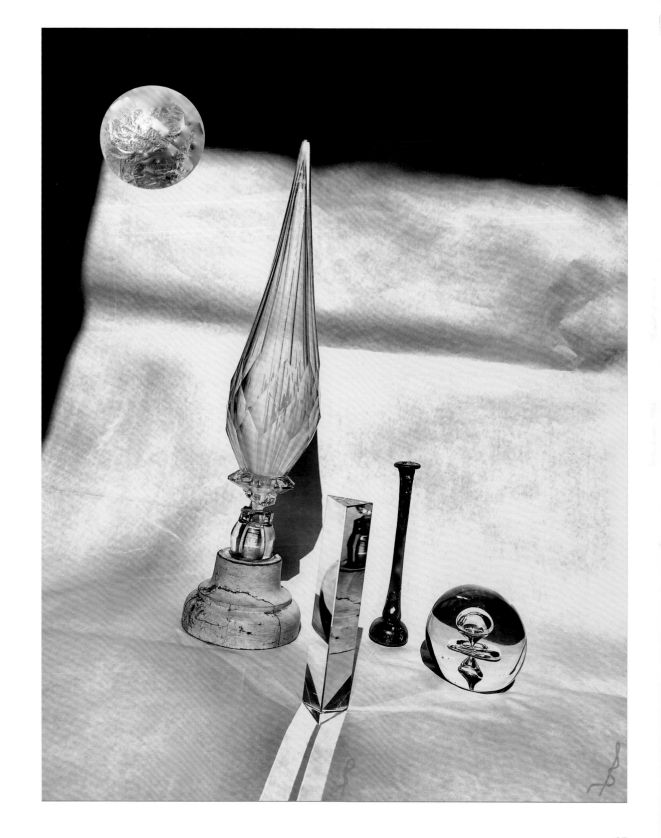

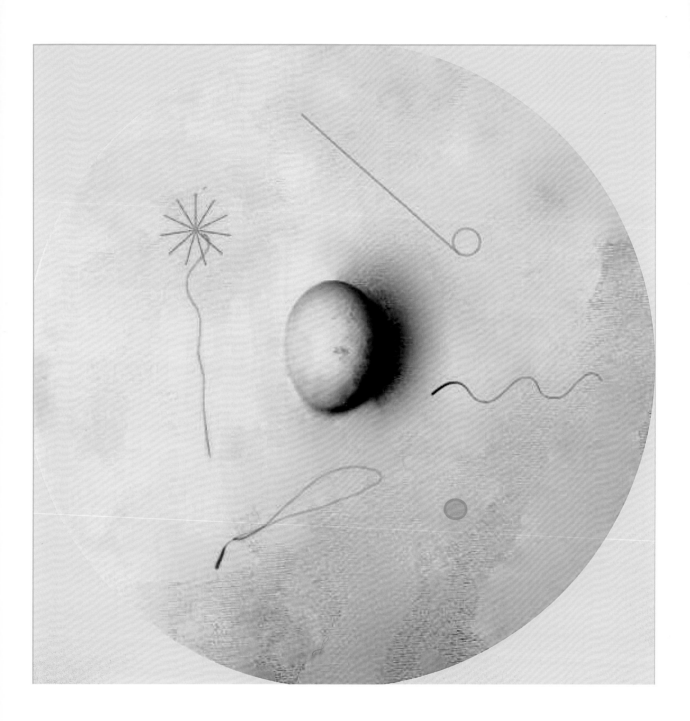

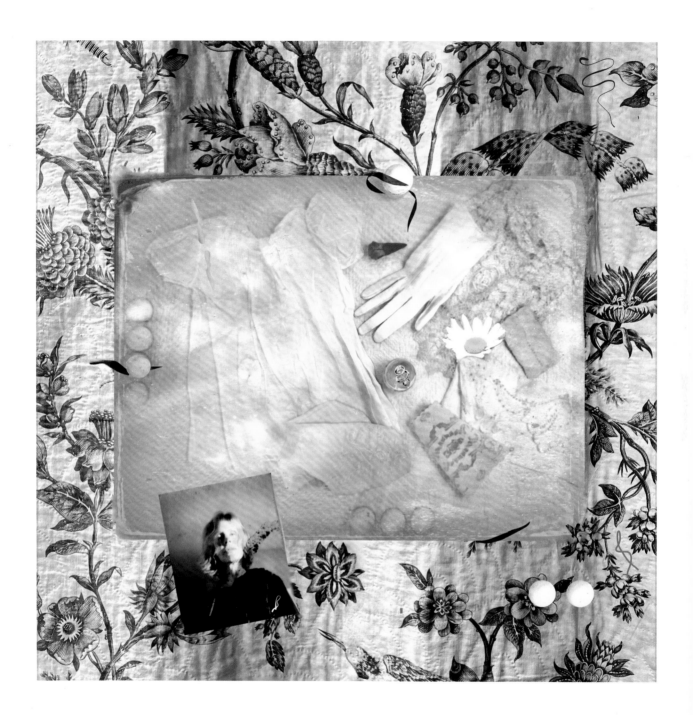

He gathered his christening gown, his mother's wedding glove, a raven's skull he'd found in the woods behind the house, a precious cloth from a printing house near Versailles where his family tree has roots. He placed them with the photo of his beloved.

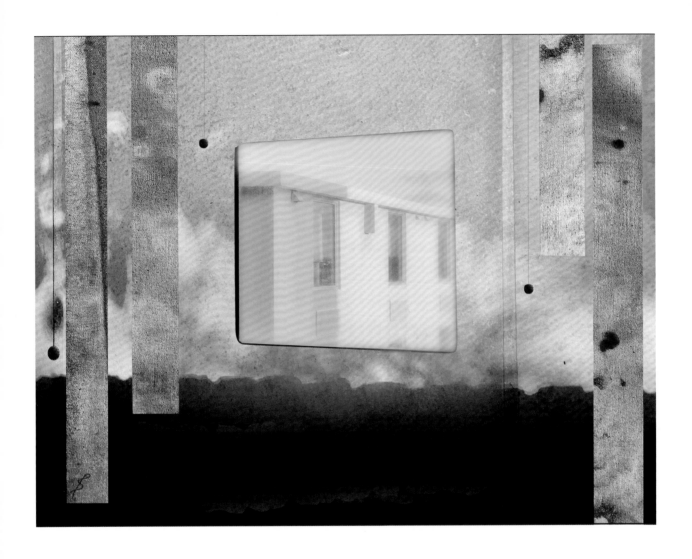

On this Saturday that feels like Sunday I wonder what Sunday will bring.

Will I wake poised for flight, tumescent, liquid crystal?

All that is left is for my spirit to escape my trappings into divine ascension, but it won't happen.

I will still be here Sunday, still swamped in mystery.

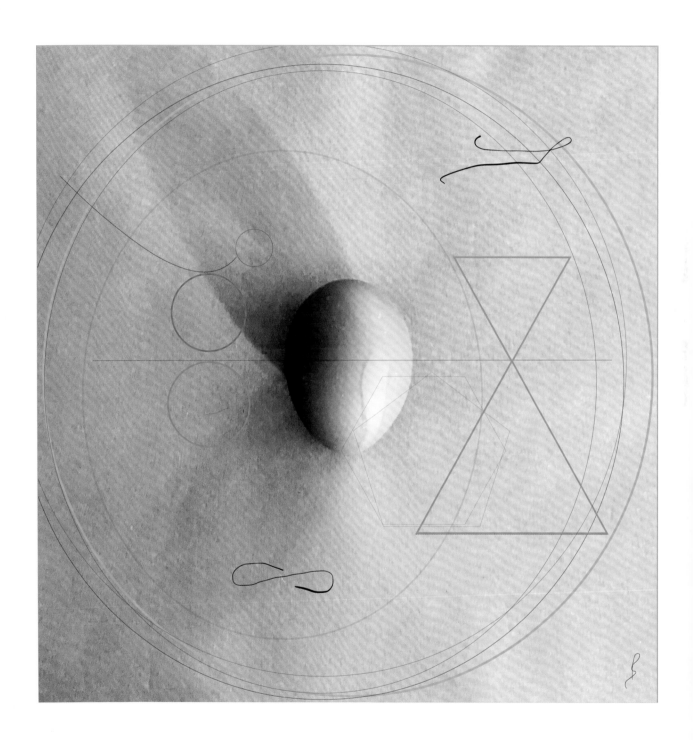

the shell is broken

life–death–life

the cycle continues

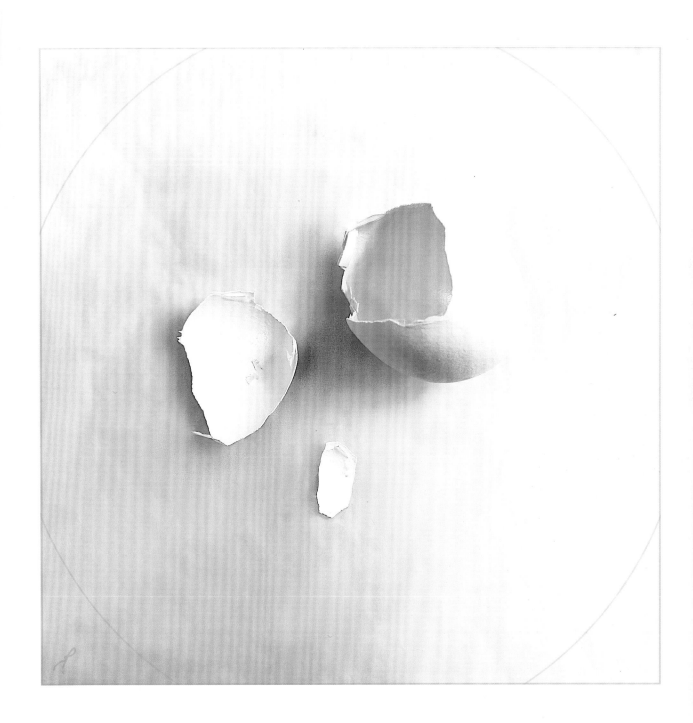

NOTES AND CREDITS

p.7: Inspired by "Altarpiece" series (1915) of abstract paintings by Hilma af Klint melding visible and invisible worlds. Hawk from ancient silk Chinese weaving. Water on right with spring cherry blossoms, on left with fall pine droppings.

p.11: Bronze statue of *Rocinante*, Don Quixote's horse, by Sharon Loper (1994) against "kaleido-wash" of print by photographer Joel-Peter Witkin.

p.13: Statue of Christ at Parroquia de San Miguel Archangel in San Miguel de Allende, Mexico. Parakeet photo by David Hume Kennerly. Melting clock from painting by Salvador Dali.

p.17: Horse jaws and other animal bones on black and gold silk velvet waistcoat designed by Emma Gaggio in classic Venetian manner.

p.20: Wood sculpture of baby boy with ball. Engraved on bottom with ST. HELL BERLIN 1907.

p.22: Australorp hen fleeing snake near her hutch, with sky backdrop over fence and miniature windmill from Iowa.

p.25: Bird on beach in Galapagos Islands moved to French cathedral with original etching by Rembrandt van Rijn of *Cornelis Claesz Anslo, Preacher* (1641) in background.

p.27: "Kaleido-wash" of c.1790 monochrome copperplate print and c.1830 multi-colored chintz with peacocks, French.

p.31: All insignia by PZS. Glass cobalt-blue pen from Venice.

p.32: Lion in fountain at Piazza Navona, Rome, Italy. Madonna and scallop shell with pearl from *The Brera Madonna* painted by Piero della Francesca (1470–1472).

p.37: Papier-mache mask on etching of court designed by Ione, with nineteenth-century silk heart pincushion and family heirloom linen.

p.43: Louis de Breze under a statue of himself on his tomb in Notre-Dame de Rouen, France, sixteenth century.

p.49: Baby's quilt c.1845. Quilt remnant in blue and white c.1880. PZS's grandmother Lyda Rose's lace choker, c.1915.

p.50: Ancient Roman ivory bust of woman under wedding veil of PZS's childhood doll.

p.58: Digitally created image of inside a human cell that went viral as the real thing. The Scottish mackerel was real.

p.60: *Angel Playing the Lute* by Melozzo da Forli (c.1480). Watercolor *Wing of a European Roller* by Albrecht Durer (1512).

p.70: Araucana hen attempting to shed her country roots.

p.72: Painting *Observatory Time: The Lovers* by Man Ray (1936) of Lee Miller's lips floating over Paris. Embroidery on silk *She goes to the window* by Rob Wynne (1994). Fabric sample c.1870 wool challis, French.

p.73: Antique Tibetan Thangka painting on silk depicting life of Buddha. Hand from marble statue *Susannah Surprised at her Bath* by Paul Cabet (1861).

p.75: The Arnolfini portrait (1434) by Jan van Eyck in antique French frame. Used meat cleaver from France.

p.79: Woodblock print *The Great Wave* by Katsushika Hokusai (1831). Photo of PZS, age four, wearing sunsuit knit by her mother and still with PZS. It should not be in the water.

p.81: Photos in triptych were color slides by PZS taken in 1985, converted to large black and white prints in 2015, hand-colored by PZS in 2016.

p.83: Sun setting at the equator.

p.84: Albatross egg photograph taken by Liz Boydston, with eighteenth-century French copperplate-print fabric.

p.90: Statue of horse in wood, with metal horseshoes and glass eyes, Italian, eighteenth century.

p.93: PZS's taciturn—except with other farmers—father as a young man, with childhood glasses.

p.95: Antique glass French finial and ancient Roman ice-blue glass perfume bottle.

GRATITUDES

First, I express my gratitude to Louise Brody for her meticulous care and brilliant "eye" in designing this, our second book, together. Louise, you are a joy to work with. I trust you implicitly.

Stephen Nachmanovitch, how grateful I am for your Foreword, and for your book THE ART OF IS on improvisation that revealed you were the (only and best) person to write a foreword for PHOTOSCAPES.

The two people who catalyzed the vision of photographing eggs as the potent symbol of daily life and the cosmos are Susan and Tom Hougan who raise exotic hens. Oh, what you launched!

Thank you, my many friends. who respond to my work and words, who know when to laugh and when to be sober, and who support my quirky visions, especially Richard Oliver, who coddled and examined each photo in detail.

Thank you, Gordon Goff, Jake Anderson, and everyone at Goff Books who accepted me and guided me through taking words and photos into a book. I am grateful.

BIOGRAPHY

PHOTOSCAPES AND THE EGG is Patricia's second photo-poetry book. It evolved out of her first photo book COMPLEMENTS: Eloquence of Small Objects, also published by Goff Books. COMPLEMENTS launched in 2021 as the #1 Hot New Release in Photography on Amazon.

Her montages and "kaleido-washes" bring together her sensual spiritual visions with her life experience of 79 years from growing up on a farm in Iowa and arriving to Washington, DC, at age 21 with no job, one suitcase, no place to live, and a handful of borrowed money. She became the photographer for the Office of Economic Opportunity where she led the documentation of poverty in the US. She taught photography at the Smithsonian Institution and had shows of her art photography.

She was an award-winning playwright and vintage quilt dealer with her collection of pre-1850 quilts exhibited at the Smithsonian American Art Museum. In 2002 she founded and directed the first global social network NGO, matching women in the US with women in 120 other nations for secure private conversations.

She was editor, photographer, and interviewer for the book SIXTY YEARS SIXTY VOICES: Israeli and Palestinian Women and Executive Director of the award-winning documentary "Peace by Peace: Women on the Frontlines" filmed by an all-female crew in Afghanistan, Bosnia, Burundi, Argentina, and the US. The film debuted at the United Nations and aired on PBS.

Photo: Max Hirshfeld

Goff Books
Published by Goff Books. An Imprint of ORO Editions
Gordon Goff: Publisher

www.goffbooks.com
info@goffbooks.com

All photographs and text by Patricia Z. Smith
Foreword by Stephen Nachmanovitch
Book design by Louise Brody
Managing Editor: Jake Anderson

10 9 8 7 6 5 4 3 2 1 First Edition

ISBN: 978-1-957183-21-3

Color Separations and Printing: ORO Group Inc.
Printed in China.

Goff Books makes a continuous effort to minimize the overall carbon footprint
of its publications. As part of this goal, Goff Books, in association with Global
ReLeaf, arranges to plant trees to replace those used in the manufacturing of the
paper produced for its books. Global ReLeaf is an international campaign run by
American Forests, one of the world's oldest nonprofit conservation organizations.
Global ReLeaf is American Forests' education and action program that helps
individuals, organizations, agencies, and corporations improve the local and global
environment by planting and caring for trees.